MW00895463

IMAGES
of America

VASSAR
THE CORK PINE CITY

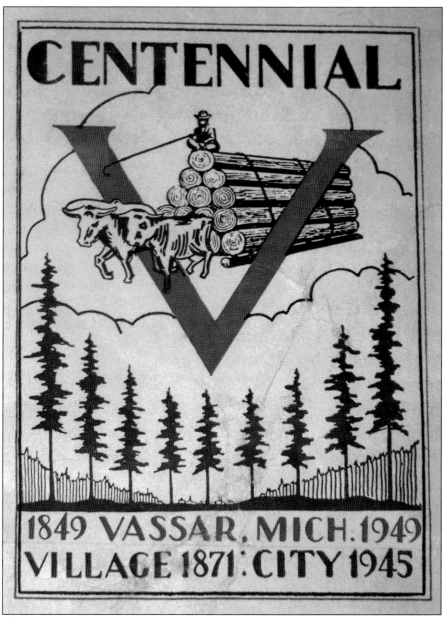

This was the official logo for the 1949 Centennial. It was used on everything including first day covers all to commemorate the occasion. The logo represents the cork pine trees that were abundant in the area and it also shows the pile of logs on a wagon heading to the sawmill.

ON THE COVER: Vassar had several dairies in the past. One of the many dairies was the Riverside Dairy. It was located just outside the village limits at the bend in the road leading to the cemetery. In this photograph is the owner William Boardman standing next to the horse and his family, the family dog, and one of the drivers. The milk house looks the same today but the house changed dramatically. (Courtesy Vassar Historical Society.)

IMAGES
of America

VASSAR
THE CORK PINE CITY

Chad Audinet

ARCADIA
PUBLISHING

Copyright © 2010 by Chad Audinet
ISBN 978-0-7385-7824-8

Published by Arcadia Publishing
Charleston SC, Chicago IL, Portsmouth NH, San Francisco CA

Printed in the United States of America

Library of Congress Control Number: 2009943878

For all general information contact Arcadia Publishing at:
Telephone 843-853-2070
Fax 843-853-0044
E-mail sales@arcadiapublishing.com
For customer service and orders:
Toll-Free 1-888-313-2665

Visit us on the Internet at www.arcadiapublishing.com

*In memory and honor of my grandmother Suzanne Rogner and
my uncle Buck Service who taught me the meaning of history*

CONTENTS

ACKNOWLEDGMENTS

The history of Vassar is a story well worth telling—that is why this book was born. It is a story of more than cork pine lumberjacks and Townsend North; it is the story of a small village that turned into Tuscola County's only city. Vassar has a lot of firsts in its life and that is why this book was so important not only to me but to Buck Service, my uncle. Some of this material is from my own archives, but without the help of the following individuals I would not have been able to complete this book. On behalf of my uncle Buck, I would like to thank my aunt Norma Service for allowing me to cherish many items from my uncle's Vassar collection. Without her graciousness, some of the images in this book would not have been printed. I also want to thank Jim Rancilio for allowing me complete access to the historical archives stored at the Bullard Sanford Memorial Library. Without him, some of the more important images in this book would not have been printed. I also would like to thank Dorothy Watt and Marjory Reamy from the Vassar Historical Society for allowing me the use of some of their archive images and making scans of those images, filling in the holes where necessary. I wish to thank Matt May and Nancy Harpham for their research skills. And last but not least, I would like to thank Arcadia Publishing Company including Anna Wilson and John Pearson for printing the Images of America series of books. It has been a dream of my uncle's and mine for 20 years to print this book, and without Arcadia Publishing Company keeping history alive, it may never have been published.

INTRODUCTION

When a person looks around present-day Vassar it is hard to imagine that this area was a virgin cork pine forest along the Cass River. The only other living soul in this area besides the wildlife was some Chippewa Indians. Most of them had moved on by 1849 but a few remained including one nicknamed Indian Dave. By the time he encountered a small party of white men, Dave was the only Native American in the area who trapped and fished in the old style. The group of men was here to settle the land. Indian Dave became a friend and an integral figure in what would quickly become a sprawling lumber village.

The lumber camp consisted at first of a sawmill and the first general store in the county. The closest settlement to what would become the village of Vassar was the Tuscola settlement, some 6 miles downriver. Otherwise this was wild country. Quickly, the little lumber camp took on life, and settlers were coming in by the wagonload. It was somewhat like the gold rush underway in California at the same time. Once word spread of the fertile farming soils and vast cork pine forest ripe for the picking, more and more people came. It became clear very early on that this lumber camp would be a major settlement in this part of Michigan, which itself was still in its infancy as a state.

By the mid-1850s, local leaders decided Vassar would become the Tuscola County seat. After much discussion on what to name the village, it was decided to name it after Matthew Vassar, who was looking into building an all women's college in the settlement. Those involved with the planning decided the area was too wild and untamed for such a school here, so the plans were scrapped and later built in Matthew's hometown of Poughkeepsie, New York. Even though his school would not be built here, he still agreed to let his name be used for the village. Nonetheless, a proper village was laid out and it rapidly went from a couple of shanties, a sawmill/gristmill, and a general store to a major settlement. A newspaper was established, and the town's first church was built in the 1850s—both county firsts. All of this progress took place before 1860. A feud erupted between Vassar and Centerville over which was better suited to be the county seat. By the early 1860s, Indian Dave and friend Peter Bush, from Centerville, believed that even though Vassar was the first major settlement in the county, Centerville was centrally located and better suited to be the county seat. They loaded up the county records in a canoe and headed upriver to Centerville. This happened when no one was looking. The feud continued but without much steam.

Nonetheless, Vassar was a thriving little village. Fine schools were being built, and many more settlers arrived in the area to farm or establish a business. Vassar became known as the "little big town of Tuscola County." It contained all the amenities that one would find in a big city. An opera house was built, two railroads were established, many manufacturing plants and businesses were established, and Vassar was well on the road to living up to its nickname. The start of the 20th century saw many more developments and changes. Vassar was now 51 years old, and with so many things to do and so many stores to shop in, it was becoming somewhat of a tourist destination. There was Beulah Park, the Cass River, several hotels, an opera house, a good mix of businesses, and much more.

One thing Vassar became known for were the floods that hit every spring. Most of downtown Vassar and some of its residential areas lie in a low area just below a rolling hill on both sides of the Cass River, so floods became part of life for many. In the 1930s, the art deco fad hit Vassar; some of the downtown buildings were remodeled in this style, including the lower portion of the opera house. Another prime example of this was the new theater in the middle of downtown. The Vassar Theatre was the most stylish in the county, and it became a favorite place for families and high school sweethearts.

In the 1940s, there was talk about making Vassar a city. After many meetings and talks, Vassar became the first city in Tuscola County in 1944.

In 1986, Vassar experienced the worst flood in its history to date. This flood gave Vassar a stigma that would last 20 years. In 1987 Vassar lost its beloved opera house to the wrecking ball. The loss devastated a number of Vassar residents, as did the government's continued destruction of flood-prone buildings. They formed a group that turned into the Cork Pine Preservation Association. They fought city hall and prevented the destruction of the Columbia Hotel, another major landmark and an important anchor for the downtown. The group won, and the building was saved. The building was turned over to a local businessman, and he turned the lower portion into a restaurant and desperately needed retail space. Although it had taken 10 full years, one of the flood's victims was again drawing breath. The Cork Pine Preservation Association also organized many area events including the citywide rummage sale, which continues to be a huge success—so much so that other communities have copied the idea. The association became the Vassar Historical Society (VHS), and the organization now has a museum.

Today, Vassar is in a process of rebirth. The downtown buildings have new life, the theater has undergone a major restoration, a beautiful rail trail system threads through the area, and Governor Granholm has designated Vassar not once but twice as a Cool City. The town also came up with a clever way of eliminating pumpkin vandalism during October. A group of residents came together and started the official pumpkin roll event where a person could buy a pumpkin and roll it down the hill, trying to make a basket and win a prize. This has been a smashing success and the crime rate against pumpkins has dropped. Vassar has survived the last 160 years and with so much going for it, another 160 years should be easy.

One

THE BEGINNING OF
THE FUTURE

In 1849, Townsend North and his brothers-in-law James and Newton Edmunds built a sawmill south of the present day bridge in Vassar. In 1851 it was decided that this settlement would be the county seat for Tuscola and the first trial was held. Dr. William Johnson came to Vassar in 1851 and was assigned the job of the first postmaster of the settlement as well as the first physician in the county. Townsend North built the first general store in the county near his sawmill. Vassar also had the first newspaper printed in the county: *The Pioneer*. The settlement was surveyed, streets laid out, and plat was drawn and recorded by 1854. Townsend North and the Edmund brothers began to discuss what to call their little village. James Edmunds suggested the name Vassar after his uncle, brewer Matthew Vassar. Others agreed and the little village was called Vassar. The first home built in Vassar was built by B. F. McHose on North Main Street in 1855. The first brick building was built also in 1855. The population in 1855 consisted of 74 men, 39 women, 35 horses, 5 cows, and 12 pigs. By 1860, a feud between the villages of Vassar and Centerville was at times very heated as both villages thought they were the best location for the county seat. Indian Dave and Peter Bush took all the county records from Vassar via canoe and headed upriver to Centerville thus making it official that the county seat would forever be in Centerville.

On September 10, 1867, residents of the township delivered $3,000 worth of bonds to the president of the Saginaw, Vassar, and Sanilac Plank Road Company. That went to build the first plank road between East Saginaw and Vassar, thus opening up Vassar to the outside world. The residents of the village took a vote and incorporated the Village of Vassar in 1871. Townsend North passed away peacefully in 1889 and was laid to rest in Riverside Cemetery, which overlooked his village.

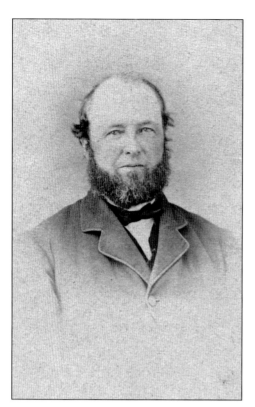

This is the earliest known image of Townsend North, taken a few years after he first came to Vassar. He was around 50 years of age at the time, married, and had three children. (Courtesy Bullard Sanford Memorial Library.)

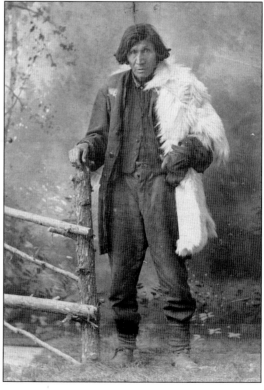

This is the earliest known image of Indian Dave. This rare image shows him sometime in the 1870s when he was in his 70s. He is shown with a fur pelt over his shoulder. Looking at this photograph it is easy to imagine him living in his wigwam, which was located outside of the village. (Courtesy Bullard Sanford Memorial Library.)

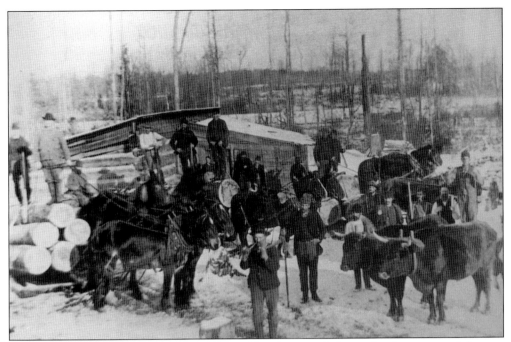

This is a very early look at lumbering in Vassar. This photograph shows a lumber camp and the men who worked at it. This photograph was taken in the 1850s, when Vassar was just beginning. By the looks of the photograph, it was a productive and busy day. (Courtesy Vassar Historical Society.)

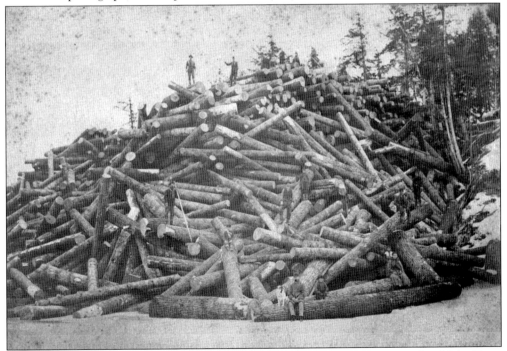

This rare image shows a huge log pile near the banks of the Cass River just outside of the village, a good representation of what logging was like in the Vassar area in the 1850s. The pile of logs is two stories tall. (Courtesy Vassar Historical Society.)

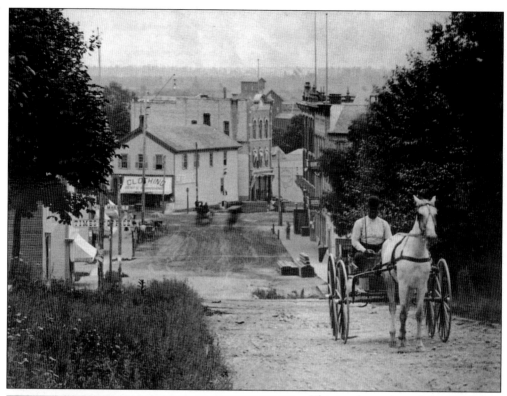

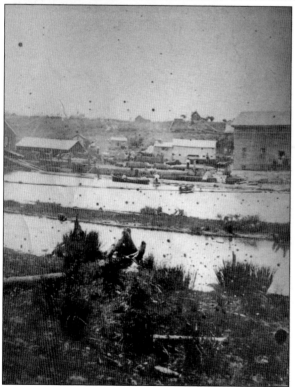

This is a later view of the plank road that connected East Saginaw and Vassar. Today it is known as M15. The rare image shows a lone horse and buggy coming up the hill. Notice the opera house and Jewell House were already built, but the Gilchrist building was still a wooden structure. This dates the photograph to the early 1880s. (Courtesy Vassar Historical Society.)

Here is the earliest-known photograph showing the original sawmill complex built by Townsend North and his brothers-in-law, James and Newton Edmunds. The photograph looks across the river from present-day Water Street. The complex stood where the Reliance Mill would eventually be built. The photograph was taken in 1863. Notice how sparse the area was. (Courtesy Buck Service)

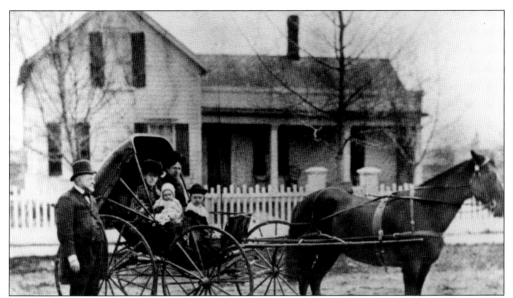

Townsend North is shown with his second wife, Celia, and their two children, Ula (left) and Lena. They are shown with personal nurse Amelia Trounjeau (on the right side of the buggy). The photograph was taken outside of the original North home at 127 South Main Street just prior to the family's moving into their spacious new home. The photograph was taken in 1883. (Courtesy Bullard Sanford Memorial Library.)

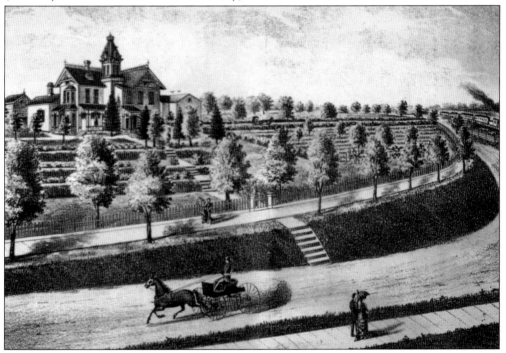

This is an artist's view of the new North home on North Main Street. This home was built in the mid-1880s and was done in the Eastlake style popular at the time. The home came with a cupola from which, on a clear day, a person could see smoke rising from Centerville some 40 miles away. (Courtesy Bullard Sanford Library.)

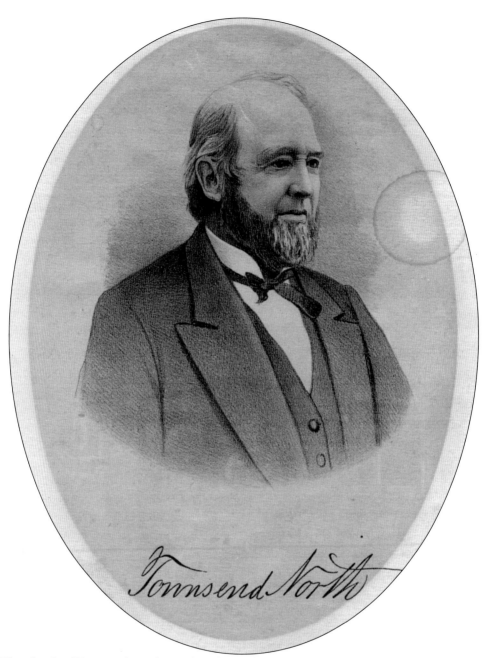

This sketch of Townsend North was done late in his life. By this time, North had lived a life full of adventures and discoveries. He was born in 1804 in the state of New York to a carpenter and his wife. By 1836, North followed his father to Michigan. He was one of the subcontractors to build the first dormitory for the University of Michigan. He moved to the Flint area and operated a hotel. Over the course of conversation, Townsend North was given the contract to build the first bridge in Saginaw County. In 1849, Townsend North and James and Newton Edmunds received 3,000 acres to do further improvements in the valley. They established a sawmill in what would become the Village of Vassar. North was married twice and raised seven children. He passed away peacefully in 1889 at the age of 85. (Courtesy Bullard Sanford Memorial Library.)

Two

LITTLE BIG TOWN
OF THE THUMB

Vassar was a prosperous lumber town that grew quickly. The nearest village was Tuscola; the village of Frankenmuth was just down the road from there. Vassar had great schools, churches, two railroads, several overnight accommodations, an opera house, and a great mix of businesses and manufacturers, including the Vassar Woolen Mills, Butcher Folding Crate Company, brickyards, drugstores, and an assortment of mercantile and dry goods dealers. In those days it was a good one-day trek to Saginaw (some 40 miles away), so by providing important "big city" goods and services to its neighboring communities, Vassar quickly became a regional commercial center. Soon the village had gained the nickname, "the little big town of the thumb," which was later joined by the title, "the hub of the thumb," itself a reference to Vassar's location at the point where Michigan State Highways M38 and M15 meet.

Coming into town from the south, travelers first came to Clark's Roadside Park just outside the city, and right next door to the park was Blondie's Hamburger Hut. A little farther in town was the old drive-in A&W, complete with roller-skating car hops. Having finished lunch, visitors could then venture into the heart of town and spend all day shopping the many stores Vassar had, or taking in a movie in the 1937 art deco Vassar Theatre in the heart of downtown. After a day of eating and shopping, travelers could grab some sleep in one of the hotels and get up early in the morning to finish their trip.

REMEMBER THE TEN PER CENT OFF
ON HOLIDAY GOODS AT
BULLARD'S DRUG STORE.

Trade cards were a popular advertising medium during the Victorian era. This card advertised Bullard's Drug Store—located on the west side of North Main Street where Pam Steffan's Law Office is today. Bullard had no experience as a druggist but bought out Dr. Davis's stock and made a successful drugstore nonetheless. This card is from the 1870s.

COMPLIMENTS OF
E.J. TAYLOR & CO.
DEALER IN
DRUGS, MEDICINES,
Paints, Oils, Wall Paper, School Books, Stationery.
VASSAR, - - MICH.

Another successful drugstore was the one owned by E. J. Taylor. This drugstore was on the east side of North Main Street, almost across the street from Bullard's. This drugstore was the first in Vassar and was originally owned by Dr. William Johnson. After a few other owners, Taylor bought the business and continued the practice for several years.

This photograph shows Townsend North's eldest daughter, Mary. Mary married James Johnson in 1863; together, they owned a successful drugstore. Johnson passed away in 1879, but Mary continued the business for several more years before selling to her brother-in-law. This photograph shows Mary around 1885.

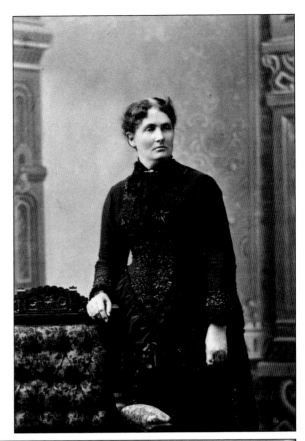

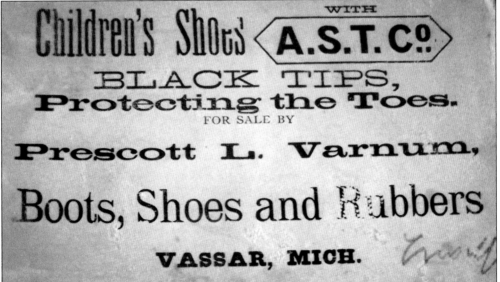

Children's Shoes WITH A.S.T. Cº.
BLACK TIPS,
Protecting the Toes.
FOR SALE BY
Prescott L. Varnum,
Boots, Shoes and Rubbers
VASSAR, MICH.

This Victorian trade card advertises one of the town's several shoe stores in the late 1880s. This shoe store was owned by Prescott L. Varnum and located in the middle of downtown where Street Light Style is located today. This store was used to getting its feet wet during the flood season. (Courtesy Buck Service.)

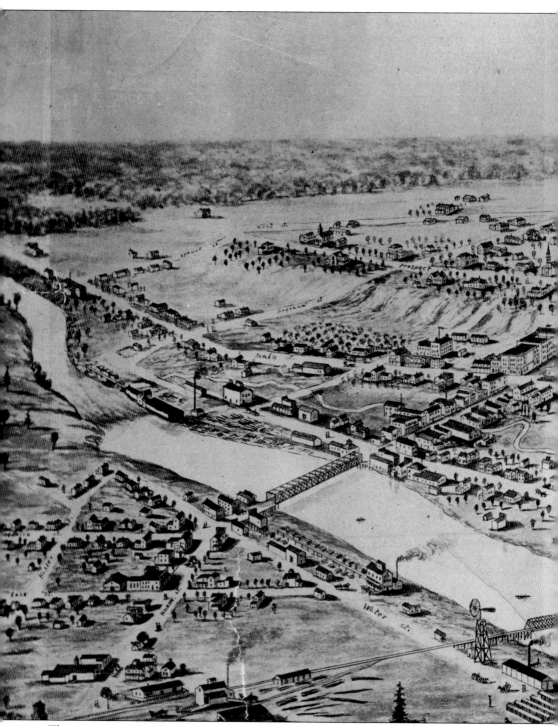

This is an artist sketch showing Vassar in the early 1880s. For a town just 40 years old, it was a sprawling village. Notice how sparse it still looked, however. Some of the streets known today did not exist at this time. There was a cemetery on North West Street. The downtown was an impressive sight, with all the brick and wood buildings including the opera house and Jewell

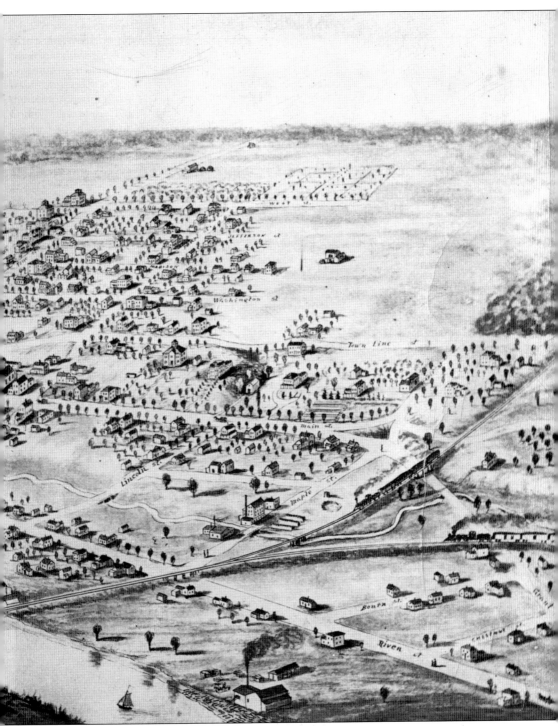

House, both built at this time. There were three churches already built. Notice that there were sawmill buildings located just off of Cass Avenue. One is at the end of Maple Street and the other was located at the end of Chestnut Street. Notice too that the original woolen mill and the brickworks were on Maple Street at this time as well.

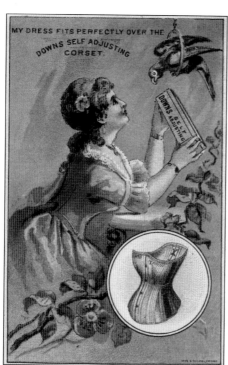

This unique Victorian trade card advertises corsets sold by Mrs. J. W. Briggs. This millinery store was on South Main Street in the same store as her husband James's jewelry store. Customers to the store could shop for a ring and a corset at the same time. This card is from the 1880s.

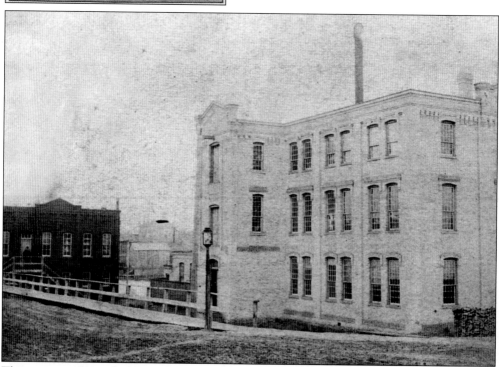

This rare view shows the Vassar Woolen Mill's second building, located where present-day Vassar City Hall is located. The mill was known for its superior quality of goods. This photograph dates in the 1890s. Notice the kerosene street lamp that had to be lit by hand every night. (Courtesy Vassar Historical Society.)

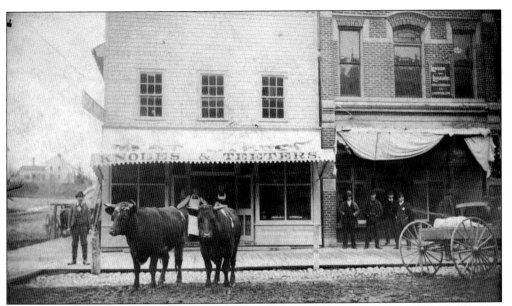

This rare image shows the corner of Division Street and West Huron Avenue. The building at this time was home to the Knowles and Teeters Meat Market. This building and the one shown to the right are now part of Cook's Budget Lot. The photograph was taken in 1895. Knowles stands inside the door to the left. Teeter is to the right of the door. (Courtesy Bullard Sanford Memorial Library.)

This rare image shows the original buildings that were on the corner of Cass Avenue and West Huron Avenue—now known as Atkins Corner. This was W. D. Purcell's Grocery and Meat Market. Purcell would hire young men during the winter months to cut river ice to put into his meat cooler. The photograph dates to the mid-1890s. Purcell is wearing all white.

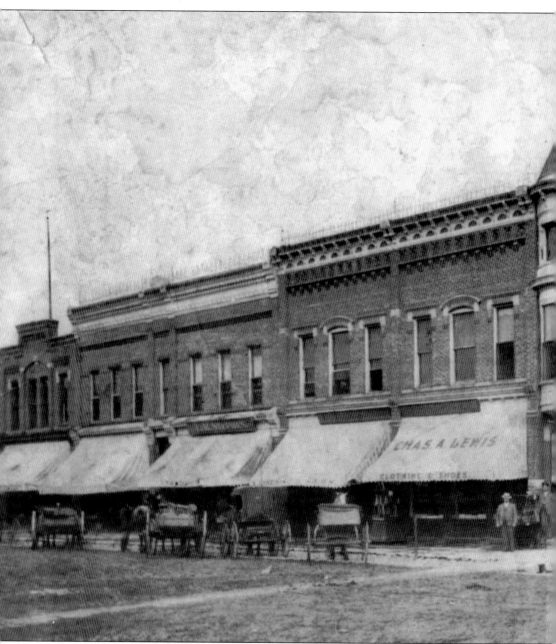

This impressive panoramic photograph shows the Charles Lewis Clothing Store on the corner of North Main Street and East Huron Avenue around 1890. The Lewis Clothing Store was better stocked than any clothing store in a big city, and it was well known in the area. Note all the horse

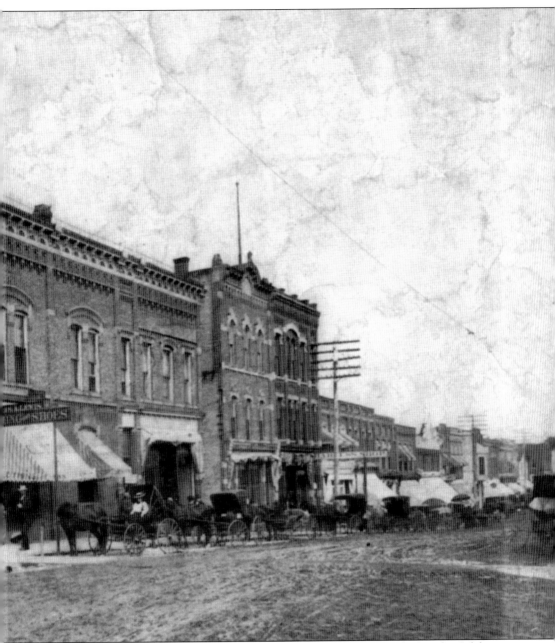

and buggies lining the street on this day. This view today has changed slightly, but the Gilchrist Building still retains the beautiful round tower feature. This building still makes an impression on people visiting the city today. (Courtesy Vassar Historical Society.)

This photograph shows the lumberyard that was attached to the Miller Grain Company located along the river near Sheridan Street. The photograph also represents how lumbering in Vassar was an important part of the local economy in the early years. A farmer could come here to buy and sell his harvest, but while here, he could also buy lumber for his farm. The photograph is from 1895.

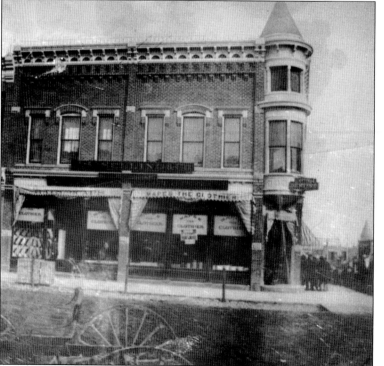

This image was taken from inside a buggy. The view shows the Mapes Clothing Store before it turned into the Charles Lewis Clothing Store. A store like this would have normally been found in a big city, but it was not surprising to find this store in the village of Vassar. The photograph dates to the mid-1890s. (Courtesy Buck Service.)

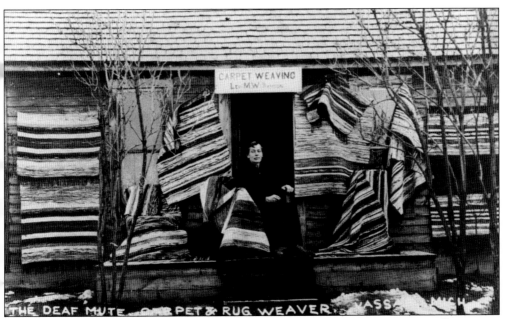

This image is another example of how unique Vassar is. This image shows Levi Williamson at his home on the corner of Spruce Street and South Main Street around 1900. Williamson, who was deaf, wove carpets and rugs for a living. He was a popular fixture and people from around the area would come to buy his goods. (Courtesy Bullard Sanford Memorial Library.)

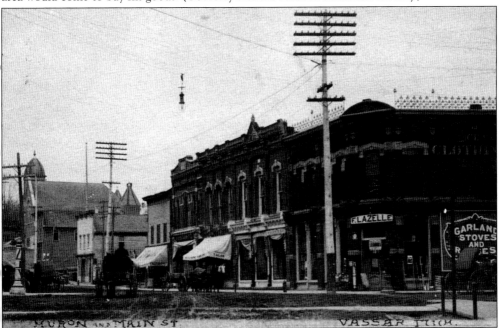

The corner of North Main Street was an impressive sight in the early 1900s. This photograph shows why it was impressive. Two-story brick buildings and one wooden structure between North Main Street and Division Street confronted the visitor to Vassar. Up the hill, where today's Hillside Park is located, stood another wood structure and the Presbyterian church. This view has changed drastically.

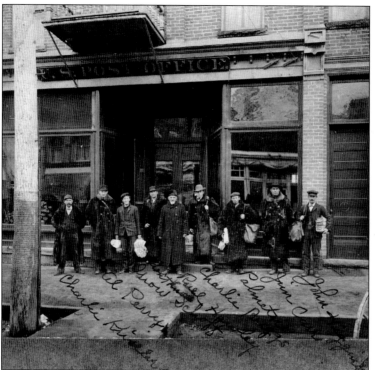

The mail carriers for the U.S. Post Office in Vassar are seen in this early 1900s photograph. This office was located to the left of today's theater. From left to right, they are Charlie Kriselar, Al Perry, Grow Schoff, an unidentified carrier, Ruel Hawley, Charlie Briggs, ? Palmeter, Jim Carr, and John Higgins. Notice that many of the men are wearing fur trench coats to keep them warm against the harsh Michigan winter. (Courtesy Bullard Sanford Memorial Library.)

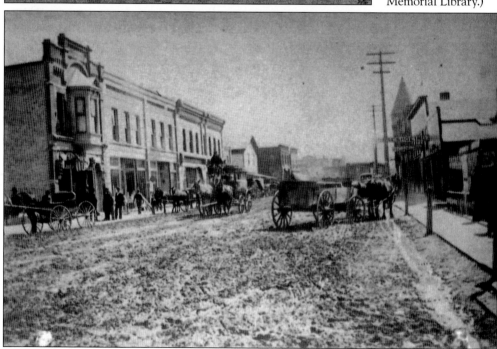

Here is downtown Vassar as it appeared around 1900. As it is even today, the town is busy in this image. Coming down the street in the center of the photograph is the Jewell House stagecoach. It has apparently just picked up passengers at one of the train stations and is heading to the hotel. (Courtesy Buck Service.)

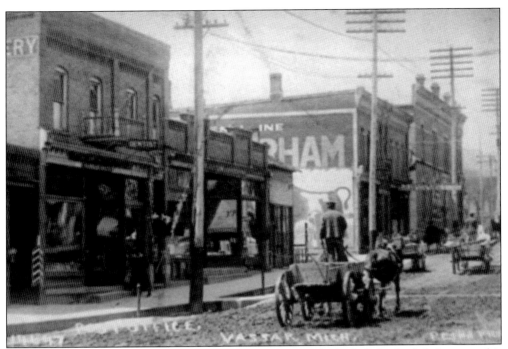

Here is another view of the busy downtown, looking towards the hill. In the left foreground is the original post office, and next to that is a clothing store where today's theater now stands. A little farther up the street is the R. D. Varnum shoe store. This image dates to around 1900.

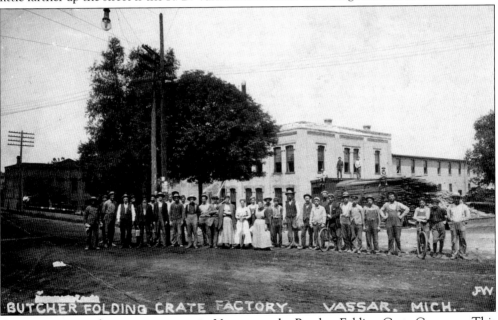

One unique manufacturing company in Vassar was the Butcher Folding Crate Company. This company built a variety of folding crates for sale to farmers and others who needed storage containers. They were well known for their folding egg crates and standing crates. The company occupied the second woolen mill building after a fire destroyed the third floor. This image shows the employees in the early 1900s.

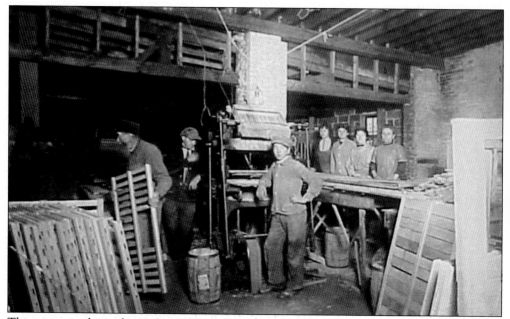

This rare view shows the interior of the Butcher Folding Crate Company around 1910. It was an equal opportunity employer; note the female workers behind the worktable. Maurice Robinson, one of the workers, is in the center of the photograph. Notice the section of crates the man is stacking—they look like animal crates. (Courtesy Buck Service.)

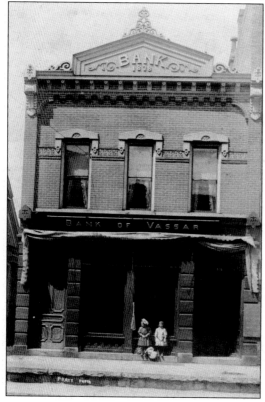

Townsend North built the Bank of Vassar in 1878. North took his only son, Frank, into partnership and named the bank T. North and Son. This firm continued business until 1883. That was when the First National Bank was organized. The bank was located next to the opera house block on South Main Street. It has now been moved to Crossroads Village and has been restored.

This was how the corner of South Main Street and East Huron Avenue looked in the early 1900s. At that time, the H. E. Harrison Drug Store occupied the building. William Baldwin, the clerk, stands to the inside left of the door, and owner Horace Harrison stands to the right. Harrison sold his business to another clerk, Claude Learn, a few years later. (Courtesy Buck Service.)

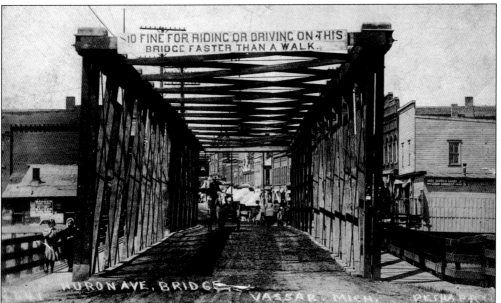

This view looks across the original Huron Avenue Bridge towards downtown around 1910. Notice the sign that reads, "$10 fine for riding or driving on this bridge faster than a walk." This was before cars were a common sight on the streets.

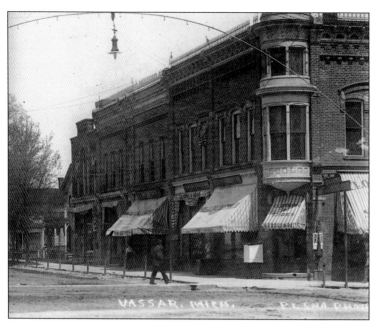

This photograph is looking from the corner of East Huron Avenue and North Main Street. Charles Lewis Clothing Store is on the front right of the photograph. T. M. Stephens Dry Goods Store was next door. The first house past the buildings was built in 1855 by B. F. McHose, who owned the Vassar Mills. This photograph is from 1910. (Courtesy Vassar Historical Society.)

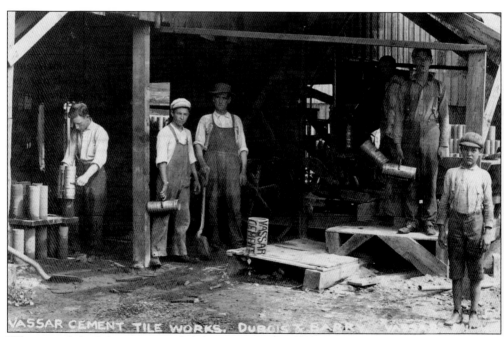

When people built homes or needed drainage tiles for their farms, they would go to the Vassar Cement Tile Works on Maple Street, where the old chimney once stood. Many homes today still use some of these tiles. This image shows the business and its workers around 1910.

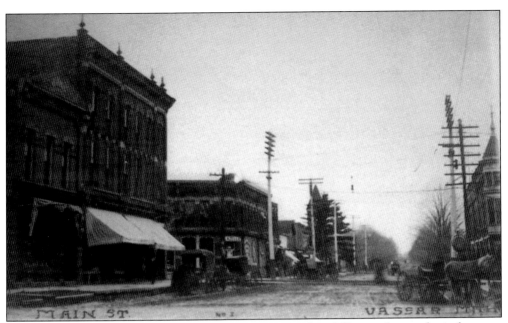

The four corners of Vassar looked much different in 1908. One difference from today is the many horse and buggies lining the streets. To the left are the North and Son Bank building with a dentist office upstairs and the Opera House block next door. The town clock building was the home of Lazelle Hardware. (Courtesy Buck Service.)

J. P. Blackmore built the Columbia Hotel in 1892. The hotel rooms were upstairs while the lobby and other public rooms were on the main floor. In 1948, A. T. Schmidt bought the building and remodeled the downstairs to "flood proof" the business. In 1990, the Cork Pine Preservation Association saved the building from being razed; it is now a thriving business once again.

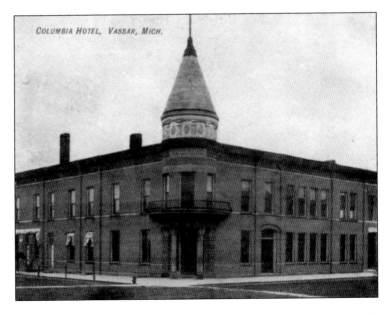

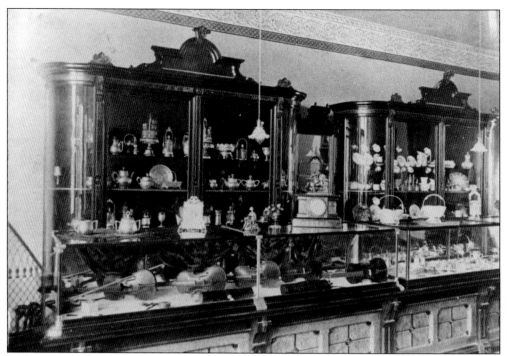

This is the interior of Wightman's Jewelry Store as seen in 1915. Wrightman's featured a wide range of glassware, silverware, jewelry, and violins. Customers could also enjoy a nice selection of eyeglasses on the same shopping trip. Wrightman's was to Vassar what Tiffany's is to New York City. (Courtesy Bullard Sanford Memorial Library.)

This unique birds-eye view of Vassar was taken from Prospect Street. This is how Vassar looked from above around 1912. Near the center is the Reliance Mill Company. The white house across the river is the DuBois home, now undergoing a complete restoration. On South Main Street near the right side of the image is a church, which was located at the bend in the street.

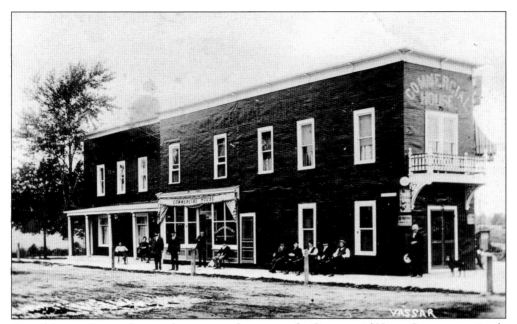

One of the town's several overnight accommodations was the Commercial House. It was conveniently located across the corner from the Michigan Central Railroad Station and owned by the Akins family. This image shows the building in 1912. It became Club 38 in later years and recently burned down. All that is left now is a grass lot—it is hard for most people today to imagine that this is how the corner once looked.

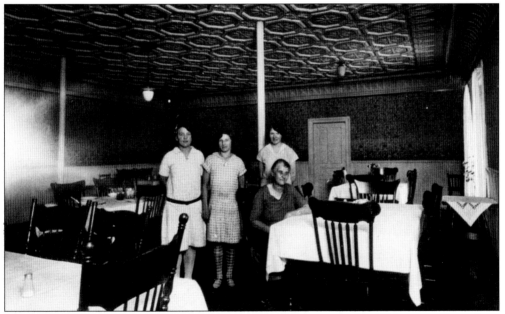

The interior of the Commercial House was very inviting as seen in this 1928 image. Shown here are, from left to right, Gusta Szymsak, Lillian Akins, Mrs. Akins (seated), and Opal Horton (Service). Many good meals were served in this dining room. It is hard to imagine that this was later turned into a watering hole and looked very different than this. (Courtesy Bullard Sanford Memorial Library.)

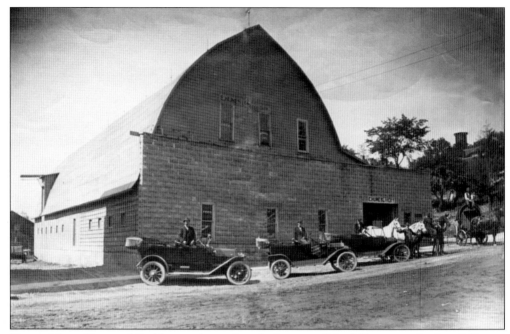

Humes Livery Barn and Stables was located at the bottom of the hill next to the Jewell House. The company would send out drivers to the train stations, and people could also store their horses here. This image shows the business around 1920. Notice they had automobiles and horses. The man in the center car is John Service. The man in the car to the right of John is Herb Service.

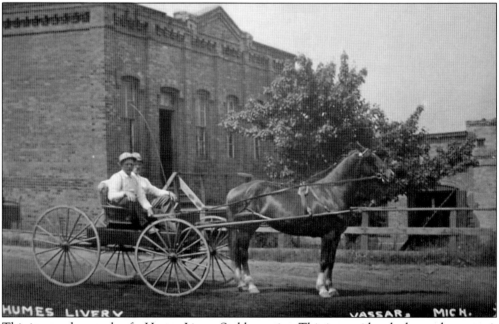

This is a good example of a Humes Livery Stable service. This is considered a horse-drawn taxi. The driver would have been a worker at Humes. He picked up a passenger and appears to have been heading towards the Michigan Central Railroad. They are stopped just east of the bridge in front of today's city hall.

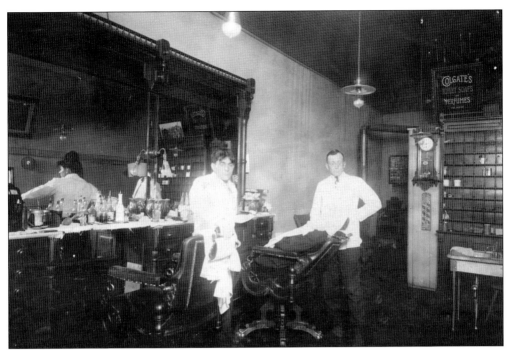

One historic building that has been torn down was the little one that straddled the drain ditch next to the theater. That building was built as a barbershop and continued to be a barbershop to the end. This image dates to the early 1900s when it was known as the Loss Barbershop. Mr. Loss is seen attending a customer. His assistant (left) looks bored.

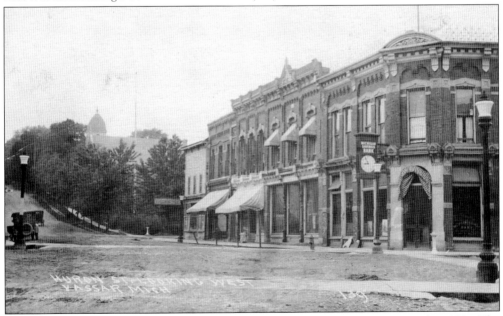

The corner of North Main Street to Division Street looked much different in the 1920s. The only building today is the town clock building. Today it is a chiropractic office, but in this view it was known as the Michigan Savings Bank. Notice that the streets are still dirt and automobiles are still a rarity.

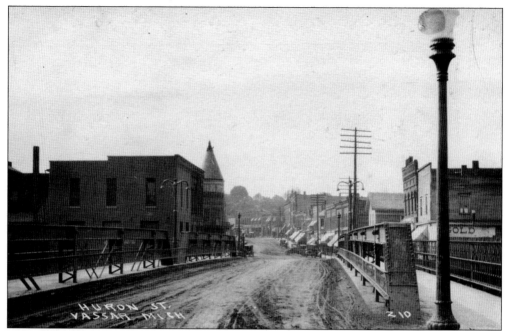

This would have been the view of downtown from the Huron Avenue Bridge in 1922. This photograph was taken in front of today's Vassar City Hall and gives a sense of how successful Vassar was. By looking at this view, someone might mistake Vassar for a suburban city, rather than the small village it was. This view has changed dramatically since the photograph was taken.

Vassar had several shoe and boot stores over the years. In those days, most people would go to the cobbler instead of buying a new pair of shoes. This 1920s photograph shows the inside of Fred Riness's shop. Here he is working on someone's boot. The shop was located by the river on what is now known as Atkins Corner.

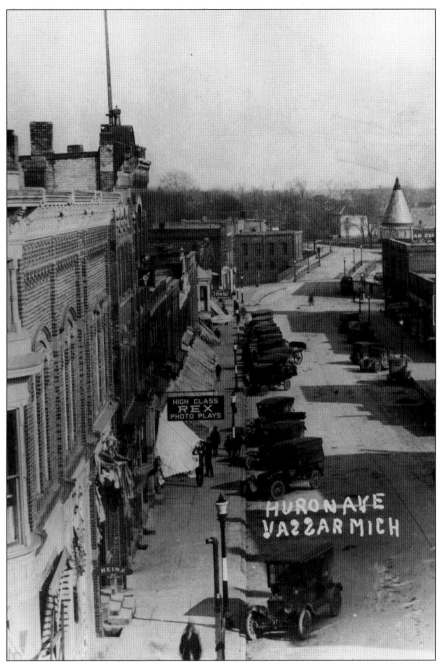

This impressive look at downtown was taken from the roof of the town clock building in the mid 1920s. Notice all the cars parked along East Huron Avenue. The building immediately to the left was the McDonald's Clothing Store. One also can see the Rex Theatre. This was the first theater in Vassar. Harry and Stan Smith owned the silent movie house. Stan would run the film while his brother Harry would hide in the backroom and bang pots, break glass, and make other noises in conjunction with the scenes on the movie. This was a big attraction in Vassar until 1937 when the Smith Brothers opened the beautiful art deco Vassar Theatre across the street. (Courtesy www.viewsofthepast.com.)

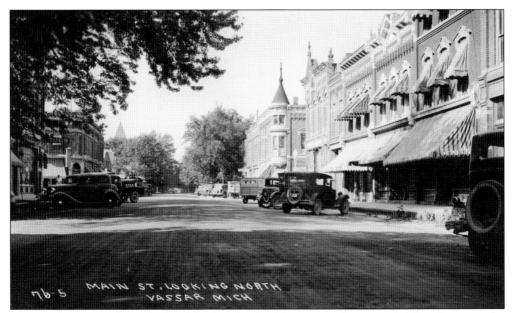

This is what visitors would see as they approached downtown from South Main Street in the 1930s. This view is drastically altered today, but in the 1930s it was a busy tree-lined street. To the left is the opera house. To the right stood Wightman's Jewelry and other stores.

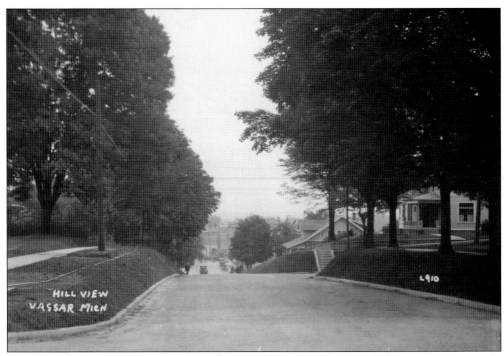

When a visitor arrived into town from the West along M15 they would be greeted by a gently sloping tree lined hill with the downtown awaiting them at the bottom. This view is how it looked in the 1930s. The view is from the corner of Madison Street. Notice the house to the right half way down the hill. When the hill was altered, this house was torn down.

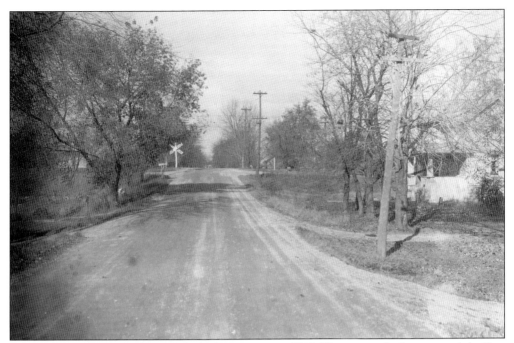

This is how M15/Goodrich Street looked to a visitor in 1928. This view is looking toward the Pere Marquette Railroad crossing and Beach Street. The depot would have been just the other side of the tracks to the right of the photograph. Notice the primitive street lamp on the telephone pole to the right. This view has changed drastically over the years since the photograph was taken.

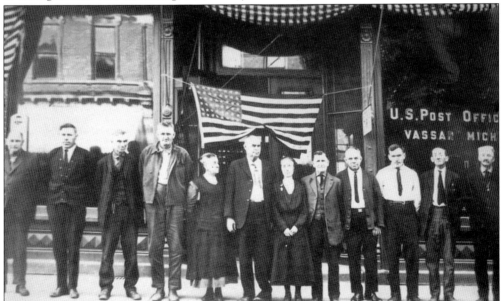

Vassar had the first post office in the county. This photograph shows the third post office building on South Main Street to the left of Wightman's Jewelry Store. This view from the 1930s shows the employees. From left to right they are Al Opalyke, Glenn Welsh, Bert Maxwell, Al Perry, Mrs. Jim Carr, Jim Carr, Mrs. Arthur Bates, Miles Osgerby, Charles Briggs, Earl Cottrell, Bernie Wellemeyer, and George Loss. (Courtesy Buck Service.)

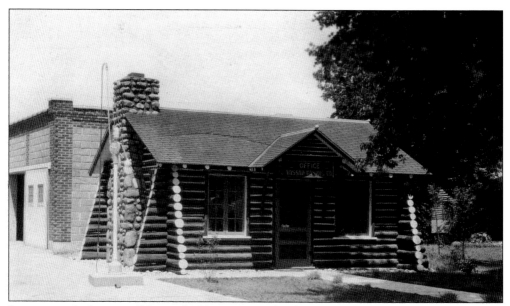

Leaning on the history of Vassar, the Vassar Gas and Oil Company built their office in the shape of a log cabin in the 1930s. Located near the corner of North Water Street and East Huron Avenue this was a landmark for many years. When the company closed, the log cabin was moved to the other side of Millington, Michigan, near the corner of Birch Run Road.

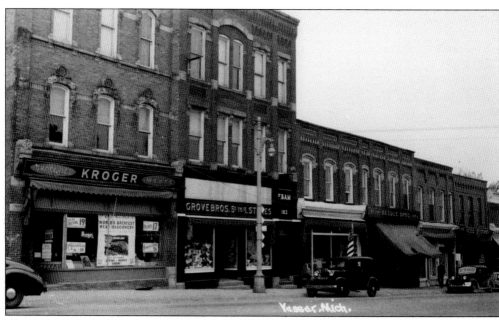

This impressive look at downtown in the 1930s shows the Kroger Store along with both the Grove Brothers and Beedle Brothers dime stores. Vassar was lucky in the fact that it had two dime stores next door to each other for many years. One would be nicknamed the red dime store and the other black for easy conversation.

Vassar was little affected by the Great Depression. A couple of the banks closed, yet people could still get their cars detailed at the Vassar Auto Laundry on Cass Avenue behind the State Bank building. This 1933 photograph shows Clarence Dedrick (left) and Harold Walker. Today all that remains is a parking lot. (Courtesy Vassar Historical Society.)

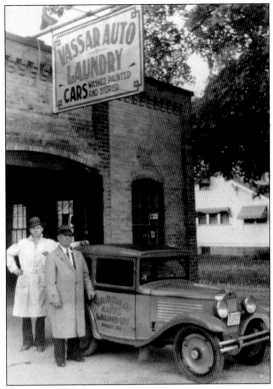

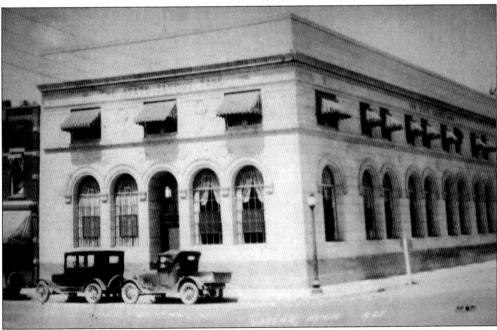

Near the end of the Great Depression, Vassar would have a new bank. Built and established in 1934, the State Bank of Vassar was a major landmark as well as a new building. On the corner of Cass Avenue and East Huron Avenue, this massive structure was a fresh breath to the downtown. This view shows the bank as a new building and looks busy. (Courtesy Buck Service.)

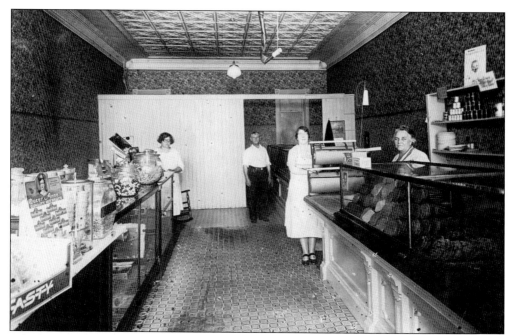

What is a downtown without a bakery? This photograph from 1933 shows the interior of Gugel's Bakery located where Mack and Hattie's Restaurant would be located years later. The employees shown here from left to right are Hattie Titsworth, Mike Gugel, Dorothy Murdick (Stoddard), and Peggy Gugel. The bakery moved across the street and in 1946 was sold to Bill Buchman and renamed the Vassar Home Bakery. (Courtesy Bullard Sanford Memorial Library.)

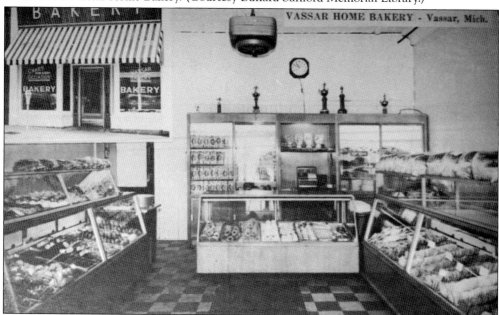

Starting in 1946 and lasting over 30 years, residents and visitors could visit the Vassar Home Bakery. Bill Buchman was the owner, and he was well known throughout the area for his fried cakes and baked beans. This view from the 1950s shows well-stocked cases full of baked goods. In 1949 the bakery was responsible for the centennial cake. (Courtesy Buck Service.)

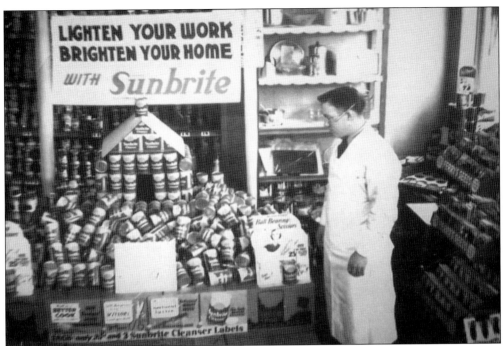

Vassar had several downtown grocery stores, making shopping convenient. This photograph shows Ed Erb inspecting a display for Sunbrite Cleaners in 1937. Erb's Food Shop was located on the corner of South Main Street and East Huron Avenue, where H. and R. Block is located today. Before it became a grocery store, the building held two drugstores. The building has changed considerably over the years. (Courtesy Vassar Historical Society.)

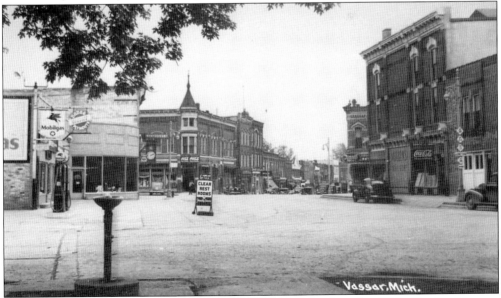

This dramatic view of downtown is looking from Hillside Park in the 1930s. To the right was the Oldsmobile dealership owned by R. D. and Mac Stacer. To the right is Miller Drug Store. This view today is drastically changed. The opera house corner is gone, as is Stacer's. (Courtesy Buck Service.)

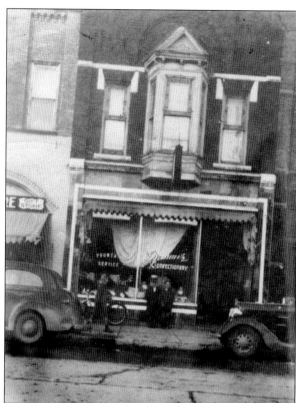

Growing up in the 1940s and 1950s had its advantages: not only did the drugstores have soda counters young people could also go to the Vassar Confectionary. Located to the left of Atkins Hardware, this was the place to be; many high school romances began with a date to the confectionary followed by a movie. (Courtesy Vassar Historical Society.)

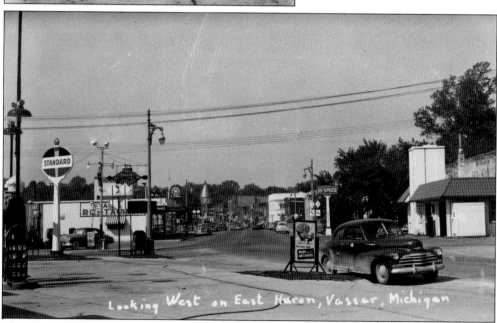

This is another dramatic view of Vassar, taken from the area of today's Betsy's Prom and Tux Store. This view looks from East Huron Avenue and Goodrich Street towards downtown. In the 1940s, this was known as "Gas Station Corners." Motorists had a choice of four gas stations to choose from. (Today there are only two.) This is how visitors traveling on M38 would see Vassar.

In this photograph are Glenn Roth (left) and Stan Jacot in the newly opened Roth's Hardware Store. The first store was located in the old North Bank next to the opera house in 1949. In 1951 the store moved downtown in the old National Bank building until 1960. They then moved next door in the old IGA building and went out of business in 1968. (Courtesy Mary Roth Rezler.)

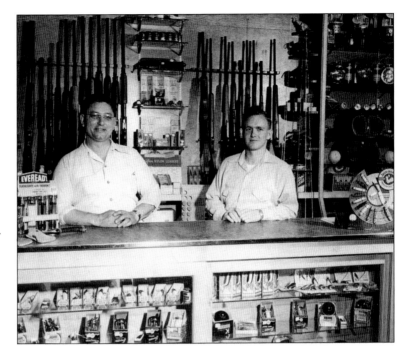

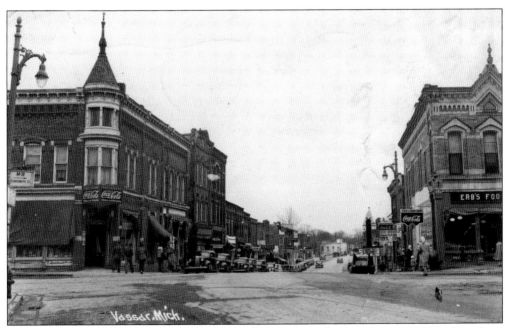

This was a typical day for downtown Vassar. This photograph was taken in 1949 looking from Main Street Corners towards the river. Notice the many cars lining the street as people shop the variety of stores that once graced downtown. On the left corner stood Burrington's Drug Store (complete with fountain service), and on the right corner was Erb's Food Shop.

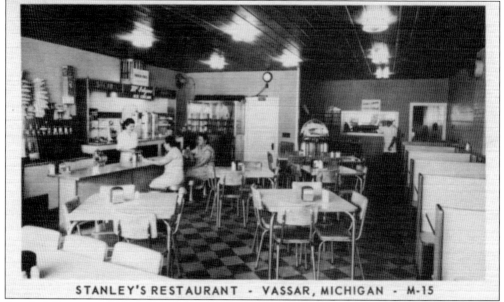

STANLEY'S RESTAURANT - VASSAR, MICHIGAN - M-15

Stanley's Restaurant was located where Speedway Gas Station is today. There were several stores on that corner, making it a popular shopping destination. Besides Stanley's, customers flocked to DuBois Hardware Store and an electronic showroom store. This interior view of the restaurant was taken in the 1950s and was one of the popular places to hang out as a high school kid.

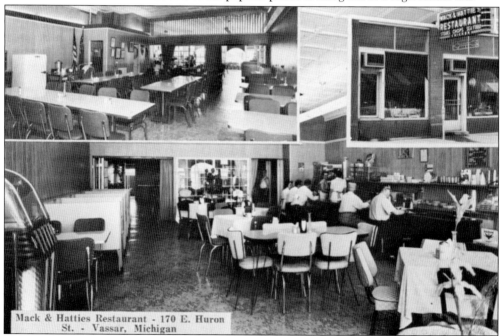

Mack & Hatties Restaurant - 170 E. Huron St. - Vassar, Michigan

Another popular restaurant in downtown Vassar was Mack and Hattie's. Located in the middle of the downtown and a few doors down from the theater, it also became a high school hangout. Well known for its hamburgers, Mack and Hattie's competed with Blondie's for teenaged customers. This was also the original site of Gugel's Bakery. Dancer's Clothing Store bought the building after the restaurant closed, and it became Dancer's shoe department.

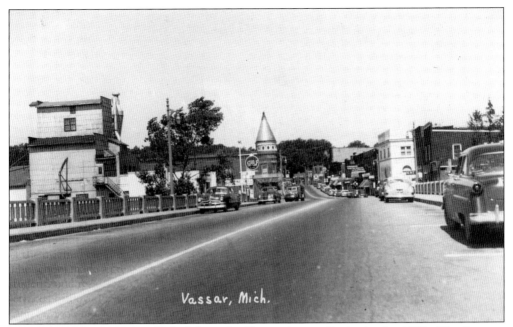

This is how the downtown looked from the Huron Avenue Bridge in the 1950s. The Farmers Elevator was located near the corner of Cass Avenue and East Huron Avenue with the Gulf Gas Station in front. Notice the Vassar Police car on the right side of the photograph. It was parked in front of the original city hall.

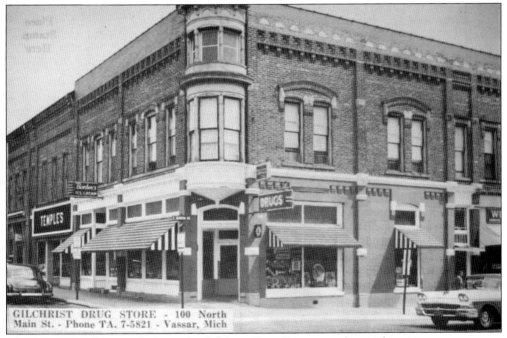

This late-1950s photograph shows the Gilchrist Drug Store, complete with an ice cream counter. This drugstore was popular well into the 1980s. It was a big city clothing store many years before this photograph was taken. (Courtesy Buck Service.)

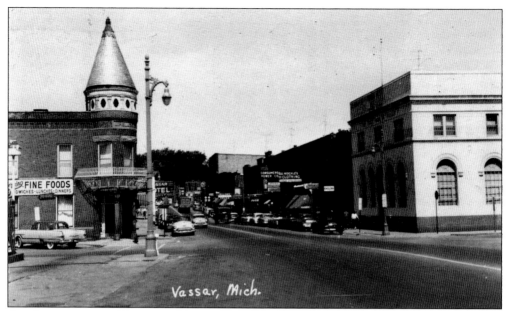

Vassar, Mich.

Another great view of downtown Vassar, this 1959 image shows a thriving business district taken from the bridge looking towards the middle of town. On the extreme left is the original Gulf Gas Station on the corner of Cass Avenue and East Huron Avenue. The Vassar Hotel is on the corner across from the gas station and the State Bank is on the opposite corner.

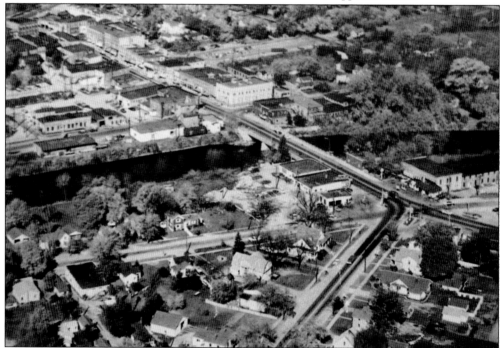

This aerial view of Vassar was taken in 1960 for a promotional advertisement. The thriving downtown nestled on the banks of the Cass River looks like a Norman Rockwell painting. You can clearly see why Vassar was the "hub of the thumb" and the "small big town of Tuscola." This view has changed dramatically, yet Vassar still retains its quaint small-town charm today.

Three

MILLER OPERA HOUSE BUILDING

One of the most beloved of all landmarks in Vassar has to be the Miller Opera House. It was the center of entertainment for many years and the only one for many miles. Erected by R. W. and F. Miller in 1879 at a cost of $7,500, the building had three stories and was built of sturdy brick made by the Vassar Brick and Tile Company. The upper two floors contained the auditorium, which featured parquet and gallery seating that held up to 750 people. The elaborate stage was one of the best in the state. Right next door to the opera house was the Jewell House, an overnight accommodation. Behind the opera house stage near the dressing rooms was a back door that opened to a very short walkway leading into the third floor of the hotel. Performers simply went through this door and almost directly to their rooms.

A few famous faces graced the stage over the years. In 1899, presidential candidate William Jennings Bryant made a quick stop in Vassar while on a whistle tour in Michigan. Silent-movie-era star Marie Dressler made her stage debut at the Miller Opera House. (She even added her signature to the many on the dressing room wall.) Back on the ground floor were an unknown store, the Miller Drug Store, and a mercantile store. In 1930, F. Miller decided to remodel the building's downstairs. He enlarged the store and redecorated it in the popular art deco style. Not only was the newly remodeled drugstore more modern, but it also featured a marble soda fountain and counter where one could buy a phosphate for a nickel. The opera house had sat empty since the 1920s, so Mr. Miller took this opportunity and turned the upper two floors into a wallpaper showroom and warehouse. Sadly, in 1987, this once grand dame of Vassar was silenced forever with the wrecking ball.

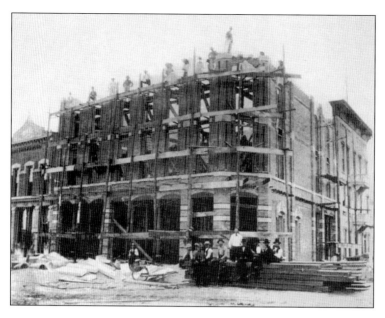

Vassar was just 40 years old at the time of this photograph, but it shows how prosperous Vassar was. This photograph from 1878 shows the men building the opera house block. The North Bank to the left was newly opened, as was the Jewell House to the right. This corner was setting the stage for Vassar's future growth. (Courtesy Vassar Historical Society.)

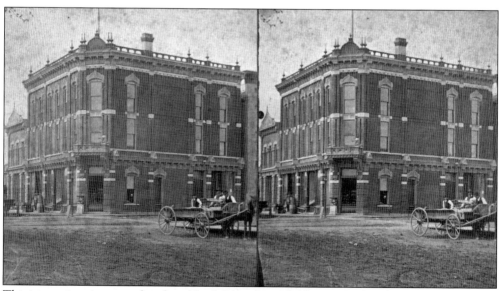

This impressive view was taken from North Main Street looking towards the new jewel in Vassar's crown. The opera house block was only a few years old at the time, but its presence made a huge statement to Vassar visitors, and was a source of pride to members of the community. This image, for instance, was made by a Vassar photographer (as a stereopticon view card) and sold as a souvenir.

This 1880s handbill shows a young Charles Harris. Born in 1867, he started his own music publishing company in 1885. He was regarded as the best American songwriter of his time, publishing more than 300 songs during his lifetime. He became known as the "King of the Tearjerker." Harris was an early pioneer of New York's Tin Pan Alley, which would become known throughout the world as a songwriting capital in the late 1800s and early 1900s.

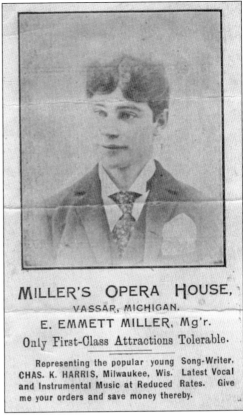

MILLER'S OPERA HOUSE,
VASSAR, MICHIGAN.
E. EMMETT MILLER, Mg'r.
Only First-Class Attractions Tolerable.

Representing the popular young Song-Writer, CHAS. K. HARRIS, Milwaukee, Wis. Latest Vocal and Instrumental Music at Reduced Rates. Give me your orders and save money thereby.

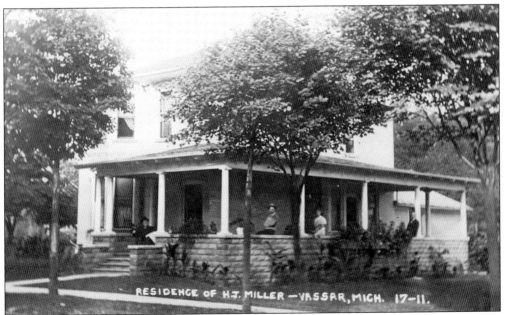

This was the home of H. J. Miller, located on the South Main Street at the bend. The Miller family can be seen relaxing on their sprawling wraparound porch. Miller could walk to his store every day if he wished. This photograph shows the house in 1910; it looks the same today.

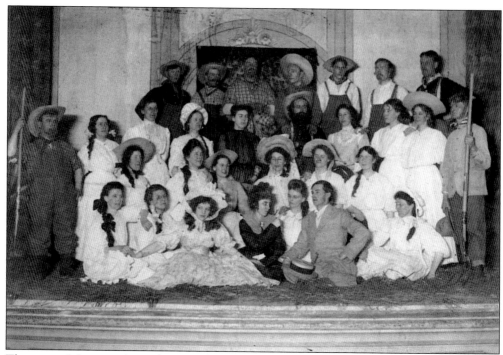

The stage of the opera house became the community stage as well. This photograph from 1914 shows a group of Vassar residents in costume for the play, *Hay Makers*. The man to the far left in the first row (in overhauls) is Henry Owen. In the second row, second from left, is Dr. Wellemeyer. In only a few years the stage would become silent forever. (Courtesy Vassar Historical Society.)

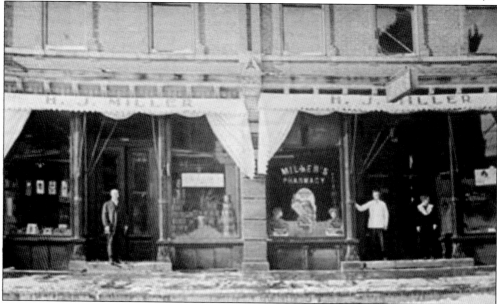

This is how the South Main Street storefronts originally looked around 1915. Miller's Drug Store occupied these two small spaces compared with the single space most people remember today. The man in the right doorway is Mr. Miller, and his wife is standing next to him. The man in the left doorway is unidentified.

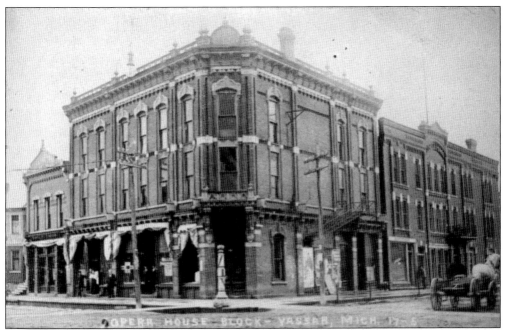

Miller's Opera House Block was still an impressive corner in this 1915 photograph. To the right is the Jewell House and to the left is the North Bank building. Notice the barber pole on the corner. This corner storefront was originally a mercantile store with a corner set up with a barber chair so that a barber could rent this corner and set up shop. (Courtesy Vassar Historical Society.)

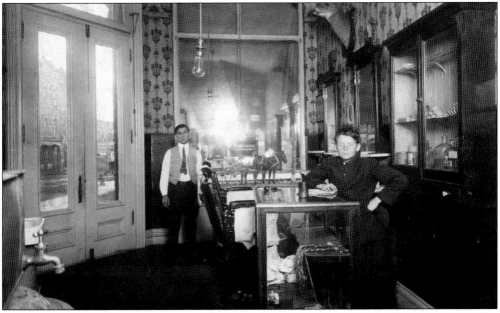

This photograph, taken in 1916, shows the original mercantile store and barbershop corner. The woman is unknown but the man by his barber chairs is Cecil Service. He left Vassar shortly after this photograph was taken and moved to Croswell where he set up shop. He was killed in France in World War I on November 19, 1918. The entire area in this photograph would become the Miller's Drug Store that people remember today.

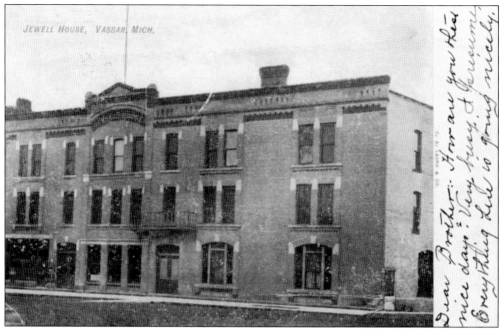

The Jewell House was a favorite resting place for weary travelers and opera house performers. A side door connected the Jewell House to the opera house for easy access by performers. By 1930 the hotel was converted into apartments and a fire started on the second floor. It destroyed the hotel, severely damaged the opera house, and spread into the North Bank. The Jewell House was torn down afterwards.

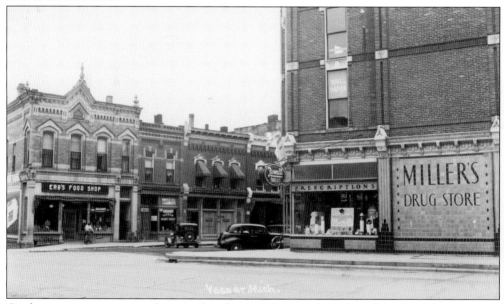

Graduation time was approaching in this photograph from the 1940s. This view is looking from the parking lot of Stacer's Oldsmobile Dealership towards the South Main Street Corner. The Miller Drug Store window display showed gifts for sale for that special graduate. Erb's Food Shop would have been another place to buy your provisions for that special party among other stores in the downtown.

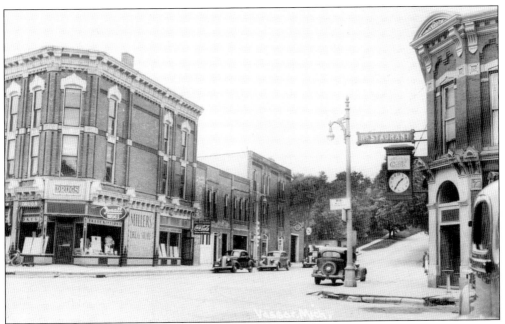

This photograph is looking from the North Main Street corner up the hill in the 1940s. On the left is the busy Miller Drug Store and on the right corner is the Town Clock Café. Customers could stop for a burger and a beer and then walk across the street and get a phosphate for dessert while they waited for their prescriptions. (Courtesy Vassar Historical Society.)

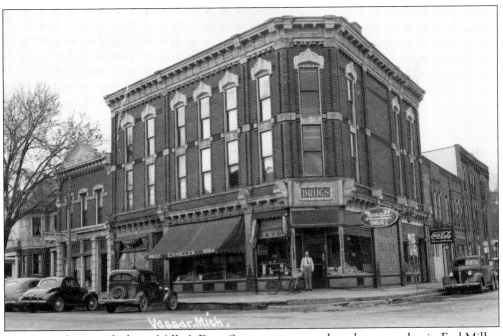

This 1951 photograph shows Miller's Drug Store as most people today remember it. Earl Miller, the owner, stands in the doorway. Upstairs, he had a wallpaper warehouse and showroom where the opera house once rang with excitement. The old North Bank was converted into an insurance office shortly after Roth's Hardware moved out.

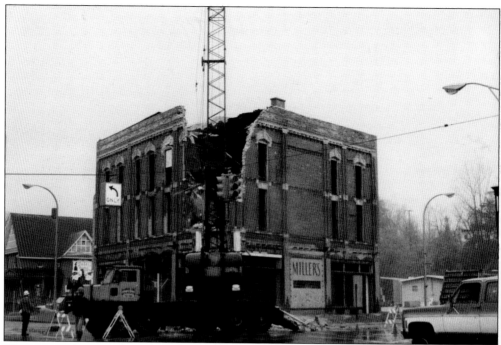

These two sad images show the beloved opera house in the stages of being razed. The event took place in November 1987 but still feels like it was yesterday. The opera house building was very special to Vassar residents, and when the news spread that this building was being destroyed so that a bank could be built, people took offense. A small group of residents started the group Concerned Citizens of Vassar, which quickly turned into the Cork Pine Preservation Association. It was too late for the opera house, but another landmark, the Columbia Hotel, was saved from the same demise. These two images are reminders that history is fragile and that historic properties must be protected. Whether embodied in a scrap of paper or a building, the past must be preserved for the good of the future.

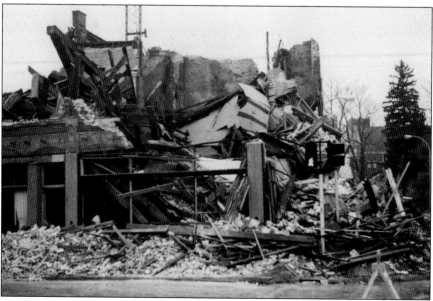

Four

ENTERTAINMENT

Vassar has always been known as a place to have a good time. When pioneers founded the new village, they made their own entertainment from musical instruments to dances and games made up on the spot. In the 1880s Vassar residents could head to Camp Phun on the banks of the Cass River below the cemetery. If they had access to a small boat, they could take a pleasure cruise up the river to Beulah Park. Those who lacked boats of their own could buy a 5¢ ticket and ride a ferry shuttle to the park. The town's opera house featured nightly performances. Town residents could fish near the dam and reel in a bountiful dinner in no time. Over the years, the fairgrounds were built, leading to horse races, carnivals, and other entertainments.

Neighborhood kids would form groups that became extensions of their families. One such group in the 1930s and 1940s consisted of the many kids in what was called the "pie-shaped neighborhood," consisting of Bourne Street, Chestnut Street, Grant Street, and Cass Avenue. All of these streets met at a point where Grant Street and Cass Avenue connected. The high school held many performances on the opera house stage and later at the school itself. In July 1949, the weeklong Vassar Centennial Celebration drew out the entire city with numerous activities. Vassar also has a city band, and on many summer nights, audiences flock to enjoy music and other programs at Hillside Park.

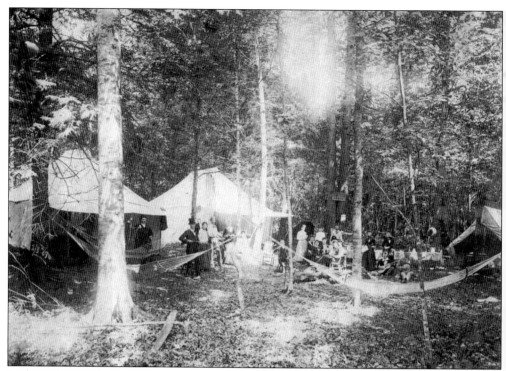

In the early years before recreational vehicles, people would take pleasure trips up and down the river and camp on its banks. One such campground was Camp Phun. Located along the Cass River under the cemetery hill, this photograph shows campers in 1889. They seem to be having a big party—perhaps a Fourth of July celebration. (Courtesy Bullard Sanford Memorial Library.)

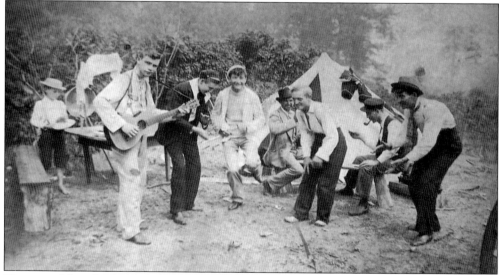

The excited bunch of men in this 1890s photograph called themselves the "Pleasure Party." In this image are, from left to right, dishwasher Harvey McLellan, J. W. McLellan, Lloyd Nelson, Walter Loranger, Will O. Clyne, Fred and Oscar Phillips, and Emery Miller. Also present was H. B. Tibbitts, who took the photograph. This group of men packed a bus and went to Bay Park for two days of fun. (Courtesy Buck Service.)

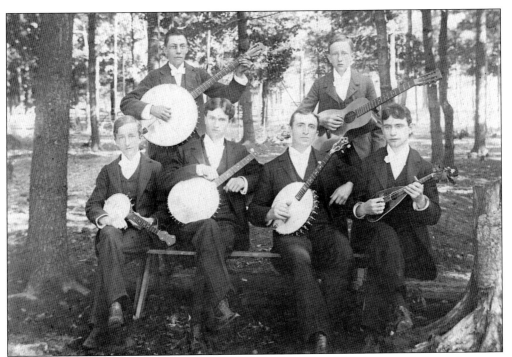

One of Vassar's earliest bands was the Vassar Banjo Club. This 1894 photograph shows the group with their banjos at Beulah Park. From left to right are (first row) Carl Forbes, George Brigman, W. O. Knowles, and Emery Miller; (second row) George Ingram and Carlton Forbes. (Courtesy Bullard Sanford Memorial Library.)

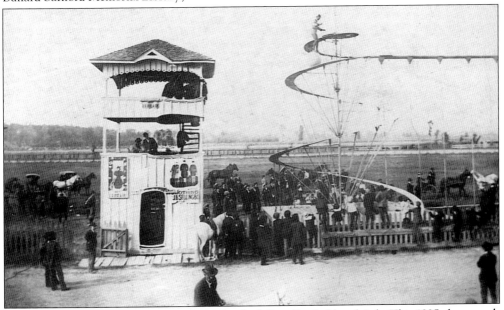

In the early days, people waited eagerly for the Cork Pine Fair held each July. This 1895 photograph shows one of the early fairs, which would have featured horse races and carnival games. In later years, carnival rides and other attractions would be added. The fairgrounds have become neglected, and the family events held on the grounds have ceased. (Courtesy Vassar Historical Society.)

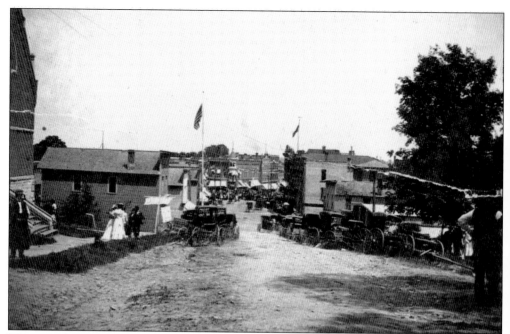

This rare photograph was taken in the 1890s from the corner of Washington Street and West Huron Avenue looking down the hill. The Presbyterian church is to the immediate left of the photograph. Notice Hillside Park had been completely built over, with no grass to spare. It looks like a Fourth of July parade day for Vassar. Notice the people standing in the streets and going down the hill. (Courtesy Vassar Historical Society.)

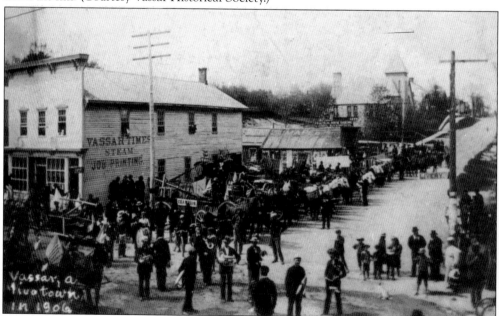

Another parade day in Vassar is seen in this photograph from 1906. This is looking up Division Street from West Huron Avenue. The home of Vassar's first newspaper is seen on the corner where Hillside Park is today. The second floor was used as a meeting hall for the Vassar GAR veterans group. The First Baptist Church stands in the background. (Courtesy Vassar Historical Society.)

60

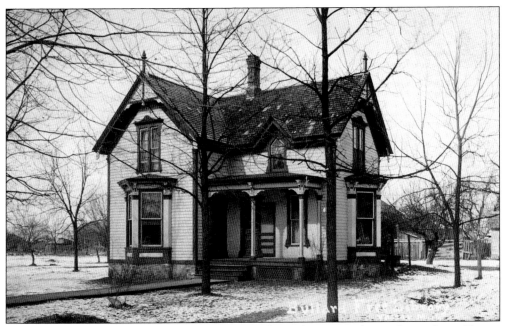

In 1906, Emma Bullard willed her home to the village of Vassar to forever be used as a library. This photograph shows the home around 1910. It was used up to the 1960s, when a new library was built on the land. Today the library has expanded and serves as the area's district library.

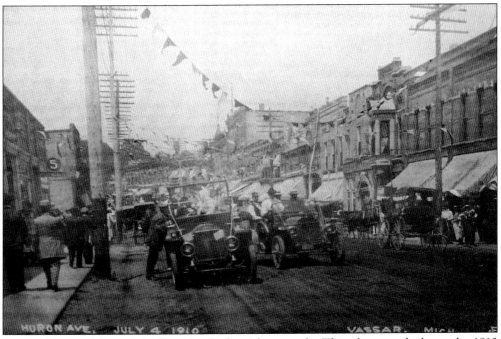

Vassar always celebrated the Fourth of July with a parade. This photograph shows the 1910 parade. Notice how the horseless carriage and the horse-driven buggies still shared the road. Vassar residents went all-out for this event with streamers crossing the road and banners on the telephone poles. (Courtesy Vassar Historical Society.)

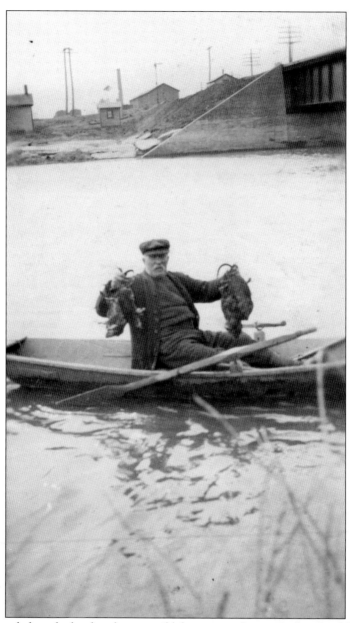

Vassar is not nestled on the banks of a tranquil lake, nor is it lining the beach of the ocean—yet Vassar has its own lighthouse keeper. This photograph was taken in 1910 on the Cass River near the train bridge that crosses Cass Avenue. The proud man in the boat is Jacob (Harry) Gibb. He was the lighthouse keeper originally for the Marquette Harbor Lighthouse before being transferred to the Crisp Point Lighthouse near Newberry. The last lighthouse he ran was the Round Island Lighthouse across from Mackinaw Island. He was a family friend of the Akins family, and when he retired, rented a room at the Commercial House. This photograph shows him proudly holding up his catch of muskrat. He passed away in 1913 and rests in Riverside Cemetery. Drive straight into the cemetery and to the left before the little side road by the chapel are Gibb's two stones, one tall and one short. The tall one is etched with the Crisp Point Lighthouse. (Courtesy Vassar Historical Society.)

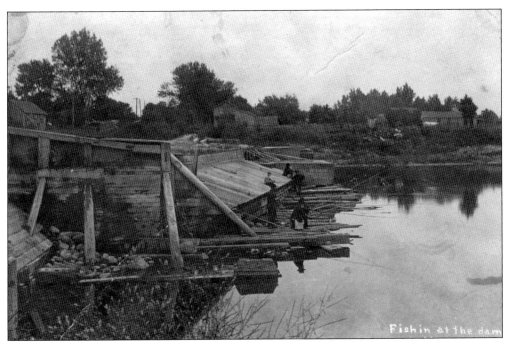

Fishing on the Cass River used to be not only a sport but also a way of providing one's family with a meal. This photograph from 1910 shows men fishing from the dam located next to Lions Park. This photograph also shows the unique construction of the original Vassar Dam.

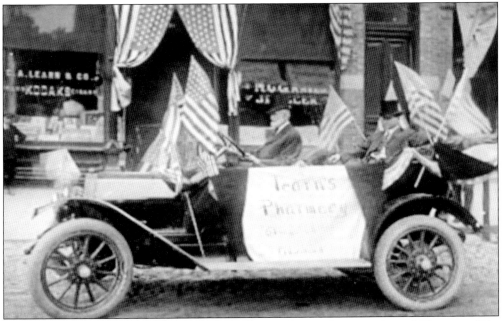

Another view of a Fourth of July parade shows the parade car advertising Learn's Pharmacy. The car is stopped in front of the store on the corner of South Main Street and East Huron Avenue. Today the building is the H and R Block office. Claude Learn sits in the back of the flag-draped car. He shared his shop with the M. C. Graves Jewelry Store.

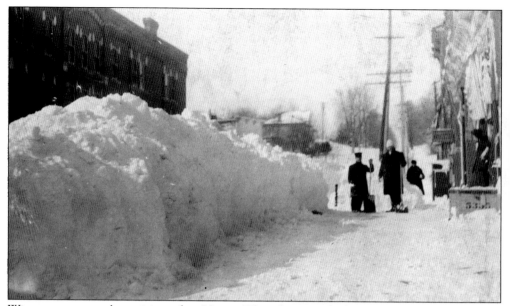

Winters were eagerly anticipated in Vassar. This photograph shows one snow pile after the February 22, 1912, blizzard. The short man with the shovel is Herb Service; the men are standing just down from the town clock building. Behind the snow pile, one can see the upper floor of the Jewell House.

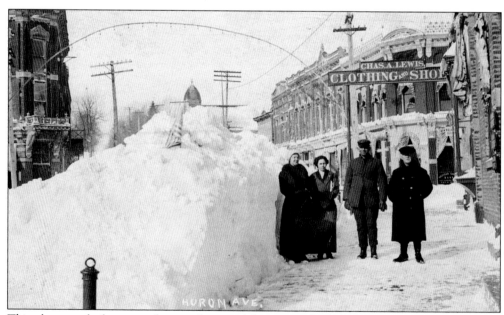

This photograph shows another good view of the snow piles left after the blizzard that struck Vassar on February 22, 1912. This group of excited people is standing in front of the Charles Lewis Clothing Store on the corner of North Main Street and East Huron Avenue. Notice the American flag stuck in the top of the snow pile.

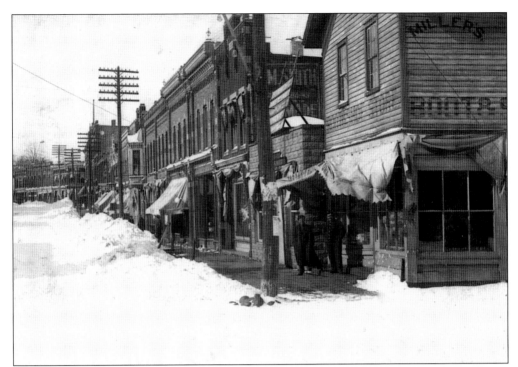

After the blizzard that struck Vassar February 22, 1912, this view from the corner of Cass Avenue and East Huron Avenue reveals massive amounts of snow. The sidewalks have been cleaned, but the street looks impassable. Notice the horse-hitching post sticking out of the snow. (Courtesy Vassar Historical Society.)

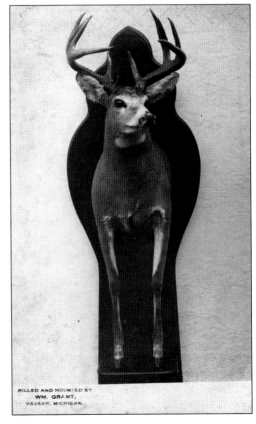

KILLED AND MOUNTED BY
WM. GRANT,
VASSAR, MICHIGAN.

A favorite pastime for most Vassar men is hunting. Once a hunter had a prize in hand, he would go to the Vassar Taxidermy. This c. 1910 photograph shows one of the many mounts by the shop's original owner, William Grant. Note the unique display of one of his prized deer: for this 13-point buck, he did a full frontal mount.

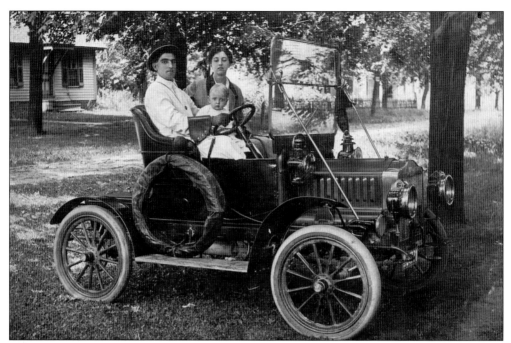

Another exciting pastime around 1900 was watching someone drive a horseless buggy. This photograph shows the second car to hit the streets of Vassar. In this 1914 photograph is the 1907 Maxwell owned by Frank Collins and his wife. They are shown with their child sitting on the corner of West Oak Street.

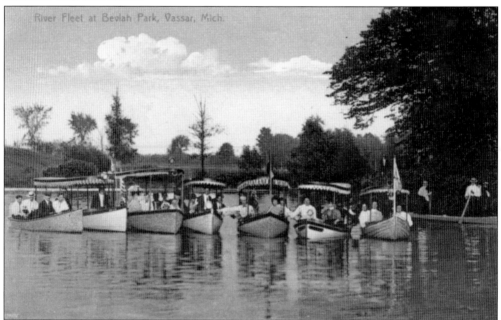

In the good old days, the Cass River was more than just a river. At the bend in the river by Kirk Road lay Beulah Park. Many people were fortunate to have their own pleasure boat, like those seen in this flotilla shown here. Boating parties like this were a common sight in the early 1900s. Beulah Park is now part of the Wolverine Human Services complex.

One such family lucky enough to own its own pleasure boat was the Herb Service family. This July 4, 1920, photograph shows the family beached on the left side of the park. George Service is the young man sitting on the bow. Herb Service can just be made out standing under the roof. The rest of the family is unidentifiable under the shadows.

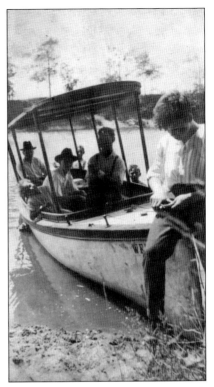

Hillside Park has changed dramatically since this 1912 photograph was taken. Notice the primitive lighting and the water fountain, both now gone. Today beautiful old trees and the band shell at the base of the hill make up the scene. In the background is the Jewell House to the right of the opera house. (Courtesy Bullard Sanford Memorial Library.)

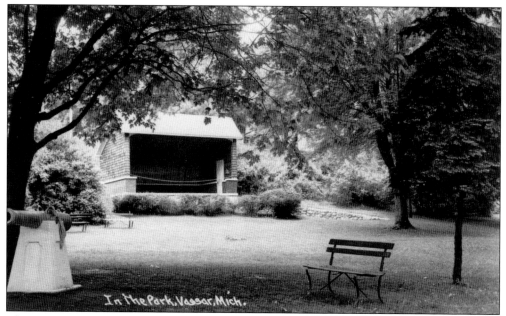

In the Park, Vassar, Mich.

This is another view of Hillside Park. This photograph was taken in the 1940s and shows the band shell built by Glenn Welsh Sr. as a gift to his city. Notice the decorative cannon, which was removed years ago. Otherwise this scene looks much as it would today. This photograph was taken from Division Street.

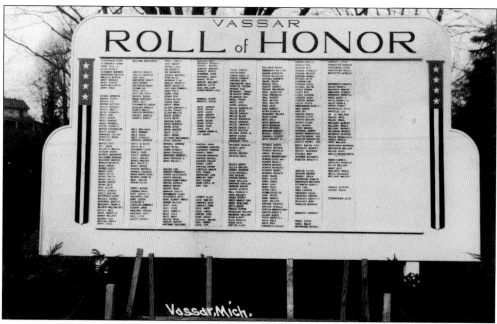

Vassar, Mich.

During World War II, Vassar showed its patriotic pride for its boys and girls who were serving overseas. One way Vassar expressed its pride was the installation of a name board located on the corner of Hillside Park. This board was hand-painted with all the names of those who were in the service.

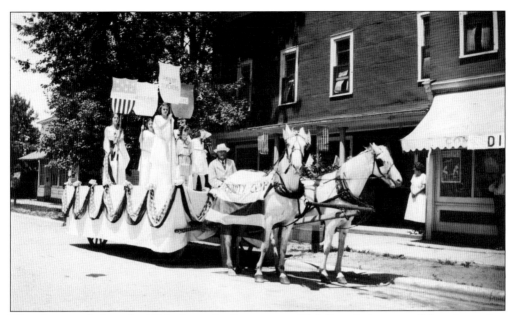

This photograph from the 1920s shows the Opportunity Club float during one of Vassar's parades. The club is parked in front of the Commercial House heading towards the Michigan Central Railroad Station. It is unclear whether the Commercial House cosponsored this float, but there would be no other reason to be so far off the parade route

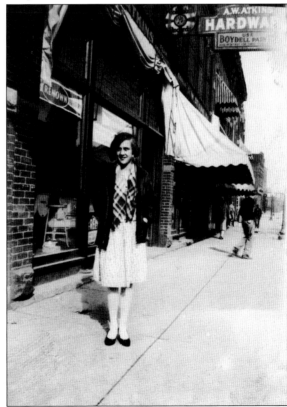

This cute girl is believed to be Beatrice Gerstein. She was a junior in 1928 when this photograph was taken. Here she is standing outside of the Vassar Confectionery, which was to the left of Atkins Hardware Store, located behind her. Notice the Atkins sign in the top of the photograph also has a Columbia Records sign.

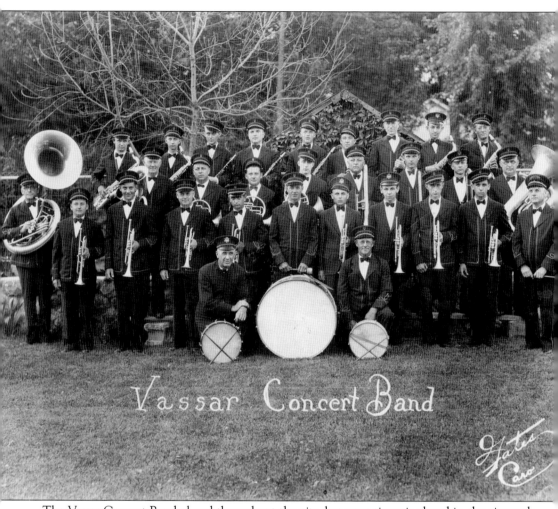

The Vassar Concert Band played throughout the city, but most times it played in the city park. This photograph was taken in Hillside Park in the 1930s. From left to right, the men are (kneeling) Ransom Park and Henry Rogner; (first row) Perry Johnson, Clarence Roth, Walter Lee, Sam Mueller, Waldermer Foess, Lewis Garner, Pete Walworth, Barton Beecher, Ozzy Neuchterlein, Grant Lee, and director Mose Simpson; (second row) Conrad Mueller, Walter Boesnecker, Herbert Roth, Unidentified, Otto Walworth, George Walworth, Walcott Pierce, and Sam Mueller; (third row) George Garvin, Harry Hawley, Curtis Hammer, Glenn Miller, Walter Boesnecker Jr., Ruben Kern, Frank Tinglan, Eugene Roth, and Jack Reams.

On September 10–12, 1936, Vassar High School held a massive homecoming fair. Located downtown, the celebration closed off the streets just like a street fair would. This photograph taken from the roof of the town clock building looks towards South Main Street. It appears that everyone was having a good time—except for the operator of the chair plane.

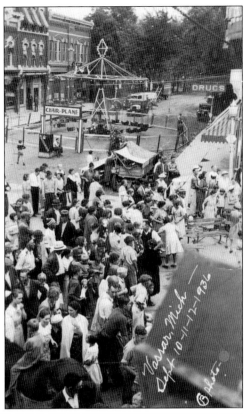

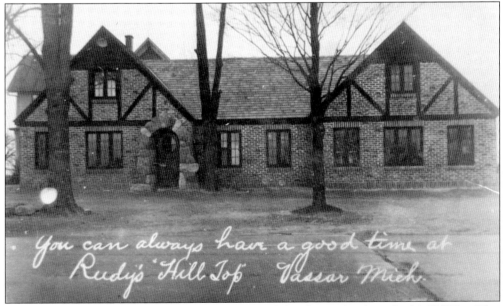

One of the favorite pastimes in Vassar is bowling and the place to bowl was Rudy's Hill Top. This view shows the alley in the 1940s, and not much has changed outside since. Located right on M15 as one enters the city from the west, it is still a popular watering hole and a place for friends to meet. (Courtesy Buck Service.)

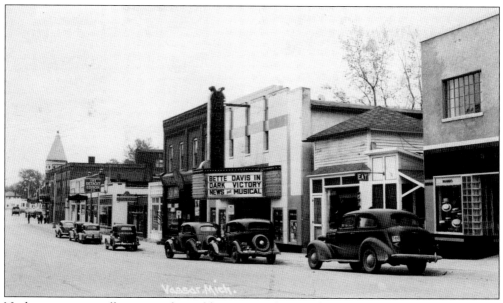

Nothing gives a small town its charm like a movie theater; the 1937 art deco Vassar Theatre is the heart of the city. The theater has undergone a major restoration and continues to be a great source of entertainment for young and old alike.

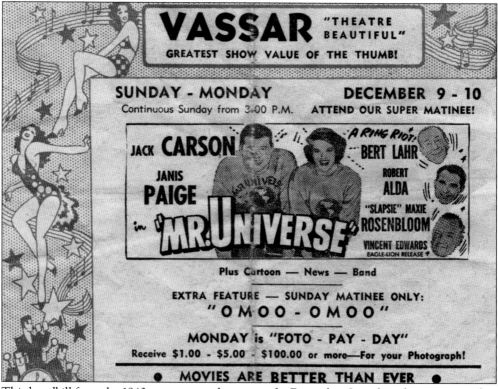

This handbill from the 1940s announces the movies for December. It is also advertising another feature the theater used to offer, which was "Foto-Pay-Day." Guests who were photographed at Monday's showing could win money in a weekly drawing.

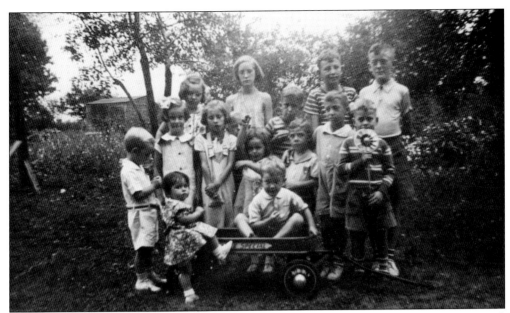

This photograph shows the Pie-Shape Gang around 1939. From left to right, they are (first row) unidentified, Mary Roth, and Buck Service in the wagon; (second row) Marilyn Lovejoy, Helen Wilczak, Cazzie Wilczak, Carol Durbin, Harry Brunet, Jerry Hile, Junior Hile, and Tom Durbin; (third row) Suzanne Service (Rogner), Dorothy Suphin, Robert Brunet, and Junior Lovejoy. All these kids lived between Grant Street and Cass Avenue.

Another pastime for Vassar was listening to the local radio channel. One of the performing groups to appear on the local stage and in local living rooms was the Vassar Vocal Airs. This photograph was taken in 1948; from left to right are Keith Parks, Harold Grazler, Wes Viele, and Charles Woodcock. Besides doing slapstick comedy, they were also a well-known barbershop quartet.

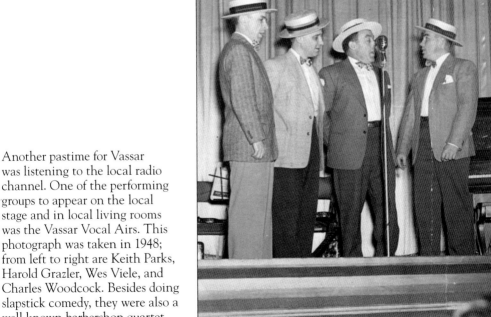

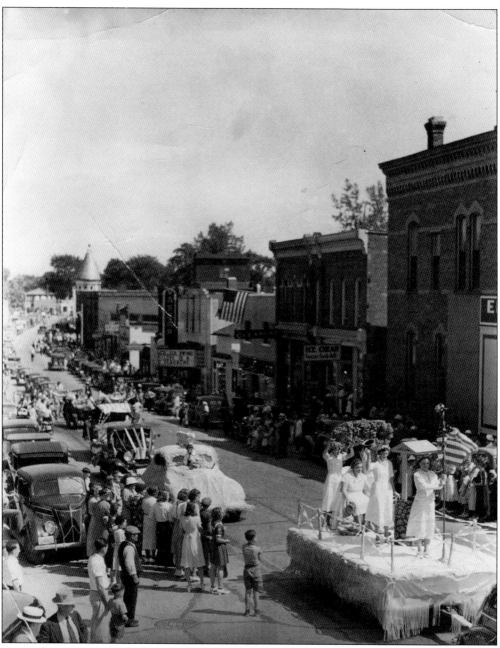

Vassar always celebrated the Fourth of July with a parade like this one held in 1945. The photograph was taken from a platform on North Main Street looking down the right side of downtown. The lead float in the photograph was sponsored by the International Order of Odd Fellows. The woman sitting is Laura Service, and the little boy sitting next to her is her son Buck Service. World War II had just ended, and you can imagine the patriotic spirit flowing through this crowd. Looks like some of the stores even flew the flag to mark this historic occasion. This photograph also gives you a glimpse into how Vassar used to be. Now many of the old buildings are gone, but Vassar still retains its small-town charm. Today the downtown is prosperous once again, but it will never be like this photograph shows.

Five

EDUCATION

Education has always been important in the history of Vassar. In the early summer of 1851, local parents and leaders decided that Vassar needed a school. A small group of people went by canoe down the Cass River to ask Augusta Slafter of Tuscola Village if she would serve as the school's first teacher. They offered her $1.50 a week plus room and board along with her meals, and she accepted. She boarded the canoe heavily loaded with classroom supplies and headed upriver. They arrived in Vassar a little wet later that day, and the next morning, Slafter led the first group of children in studies. The original school was a one-room wooden structure located on the corner of South Main Street and Spruce Street. This little school served the village well until the new school building was built on December 10, 1860. This building was an all-brick, four-corner construction topped with a cupola.

At one point, people spoke of establishing an all-girls college in the village. The land was surveyed, but a number of people worried that the area was still too wild for a girl's school, and the plans were scrapped. Two other schools were built, however. In 1869 the North School opened on Maple Street for students in kindergarten and first grade, and in 1888, on the other side of the river, the impressive brick McKinley School opened its doors for second, third, and fourth-graders. In the early years, all of the school plays and graduation ceremonies were held in the opera house as there were no facilities in the high school building. In 1916, the high school burned down, leaving four vacant brick walls. It is said that a kid not wanting to go to school the next day set the fire. A new brick school building was constructed in 1917, and this school faithfully served as Vassar High School until 1960 when a new high school was built.

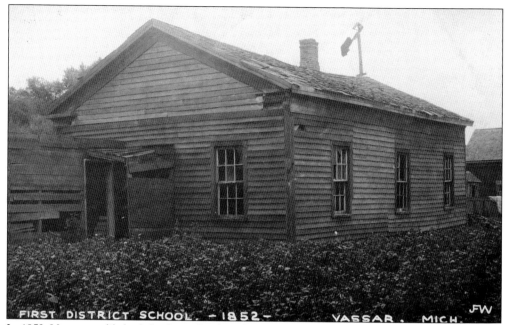

FIRST DISTRICT SCHOOL. - 1852 - VASSAR. MICH. JFW

In 1852, Vassar established the first school in the county. Located on the corner of Spruce Street and South Main Street, it was originally a shanty that was converted into a makeshift school. The building served Vassar well until 1860 when a permanent building was constructed. This photograph shows the dilapidated former school around 1910.

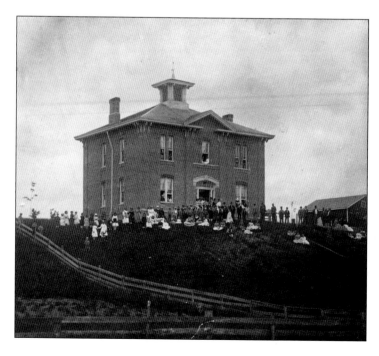

On December 10, 1860, the second school in Tuscola County was opened to students. This photograph shows the original high school in 1862. It was named the Tuscola Union School, as it not only served Vassar but the surrounding area as well. Many years later the need for a bigger school arose. The solution was to double the size of the existing school with an addition. (Courtesy Bullard Sanford Memorial Library.)

In the 1880s, Vassar needed additional schools to house primary school students. The McKinley School was built in 1888 across the river. It was originally known as the East Primary School. It was reserved in honor of the late President Mckinley in 1901. This photograph shows the school in 1913.

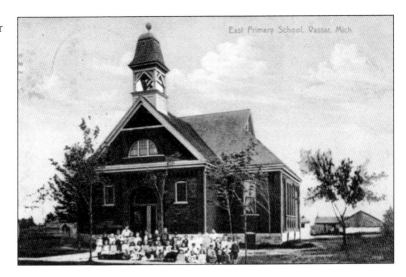

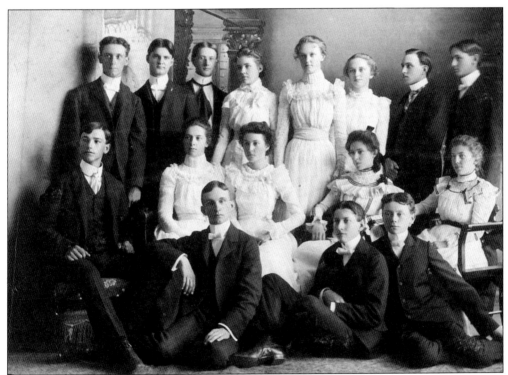

Vassar High School had a good-sized junior class in 1900. From left to right in this photograph are (first row) Orra Thompson, Helen Husted, Ola Smith, Mae Smith, Hattie Aldrich, Louis Elsworth, William Beecher, and Harold Adams; (second row) Roy Bodimer, Harold Gaunt, Clayton Stephen, Leona Livingston, Ethel Cottrell, Ella Bates, Earl Oversmith, and Lew Whitcomb. (Courtesy Bullard Sanford Memorial Library.)

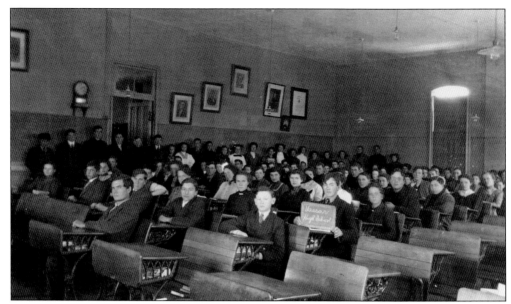

The interior of the original high school was very modern for its day. This photograph was taken around 1910 and shows the students and teachers inside one of the classrooms. Notice the primitive lighting and school desks.

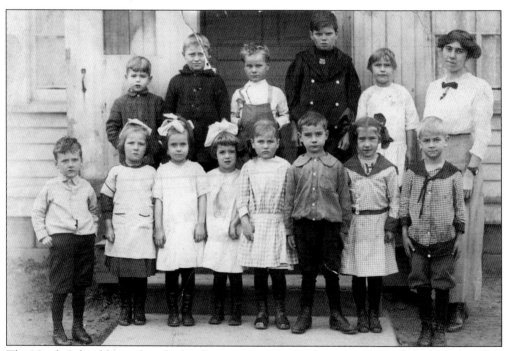

The North School housed grades kindergarten and first and was located on Maple Street. This photograph shows the students and the teacher in 1913. Pictured here, from left to right, are (first row) Melvin Stewart, Thelmas Loss, Clarissa Jones, Hope Wellemeyer, an unidentified student, Burley Service, Hazel ?, and unidentified; (second row) Carl Varnum, August Annamen, unidentified, Franklin Sinclair, Mabel Greenough, and teacher Marguerite Dibble.

Vassar High School served the village well. At one point the school district had a need for additional space, so it doubled the size of the original building with an addition. The school made a great impression on students and residents as it sat perched on a terraced hill overlooking the town. (Courtesy Bullard Sanford Memorial Library.)

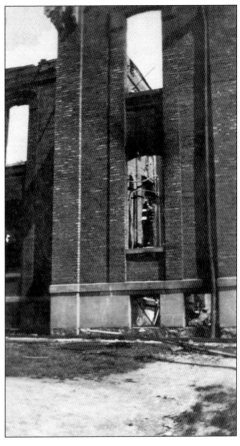

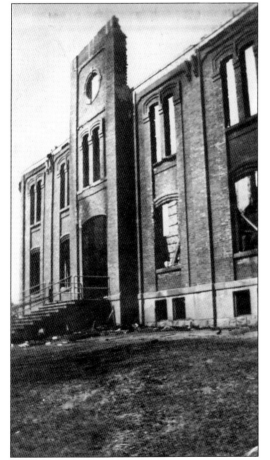

According to legend, in 1917 an unidentified student did not want to take a test and set the school on fire. The high school burned down leaving only brick walls. The students were shuffled among all the one-room schoolhouses that served the Vassar countryside until a new brick school could be built on the site. It did not take long; in 1918 the new modern school opened to the students. These two photographs show the ghostly vacant school after the fire. (Courtesy Bullard Sanford Memorial Library.)

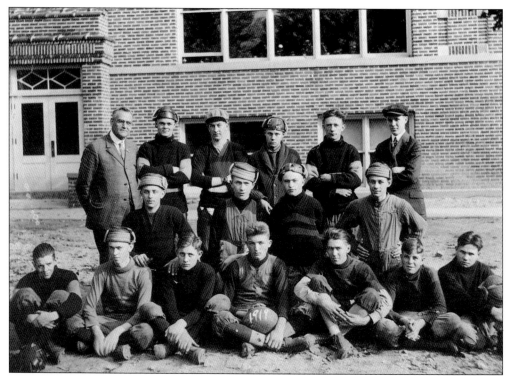

This photograph shows the 1919 football team. This team was the first to play out of the new school. Notice the uniforms; players wore whatever they could come up with as there was no uniform code. The man sitting in the first row at far right is George Service. It was noted that the team "did not do so well" the first year.

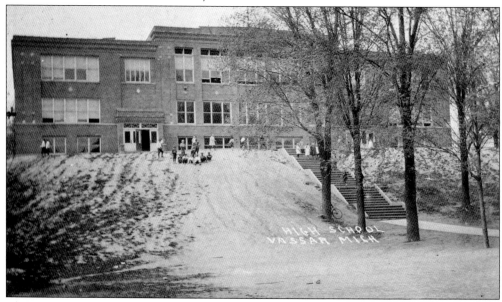

The new high school was built on the site of the original school. This school was an impressive sight and would serve the community well until 1996, when it was torn down and a new school was built down the road. This image shows the front of the new school in the winter of 1920.

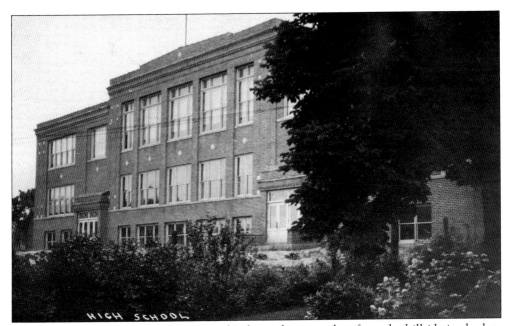

Another commanding look at the new school was this one taken from the hillside in the late 1920s. This was known as the front of the school.

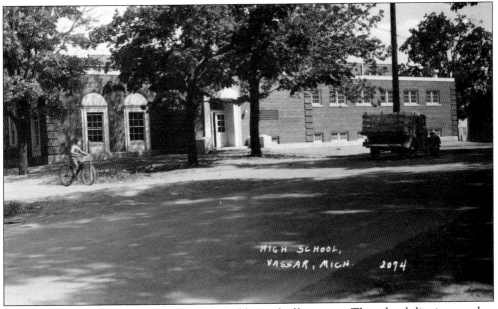

In 1930 Vassar High School was in need of additional office space. The school district voted to build an administration addition to the school, complete with a new gymnasium. This 1930s view shows the new addition, which was located on Division Street and was considered the back of the building. The gymnasium also doubled as the auditorium.

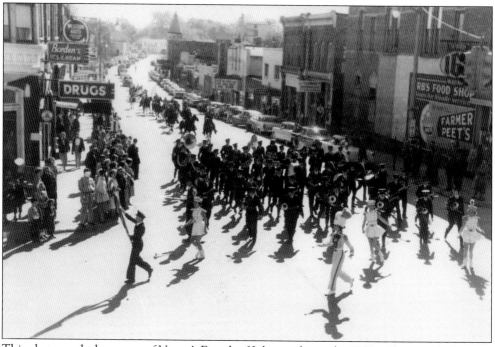

This photograph shows one of Vassar's Fourth of July parades in the 1950s. This view looks from the upper floor of the town clock building towards downtown. The Vassar High School marching band is leading the parade as they turn onto North Main Street. On the left corner was Gilchrist's Drug Store and the right corner was Erb's Food Shop.

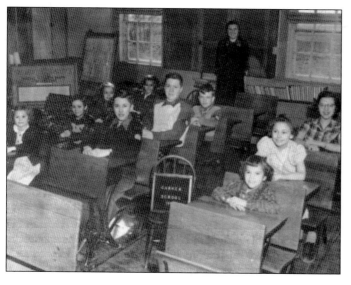

One of the many one-room schools in the countryside was Garner School. It was located between Vassar and Reese. From front to back, this 1950s photograph shows (left row) Susan Houghtling, Paul Durbin, Judy Garner, and Jane Garner; (middle row) Wally Hecht, Don Thurston, Roy Aurnhammer, and teacher Mrs. Rogers; (right row) Joan Garner, Donna Houghtling, and Shirley Weber. (Courtesy Vassar Historical Society.)

Six

ALL ABOARD

Vassar was a fast-growing lumber town, and by 1873, the Detroit and Bay City Railroad had completed its route through Vassar, which would help Vassar connect to the outside world. By 1881, the Detroit and Bay City Railroad was leased for life to the Michigan Central line, and a new, completely updated brick station was built on the outskirts of the village. This station was not the only connection Vassar had by rail. In 1882 the Port Huron and North Western Railroad completed its route through Vassar and by 1889 the Port Huron and North Western Railroad sold to Pere Marquette Railroad and they quickly built a sturdy wood station a few blocks from the other station. By the 1920s there were five passenger trains and seven freight trains each way, everyday, passing through one or both stations. People from all over were coming to Vassar for vacation, visits, or to perform on the opera house stage. Humes Livery Stables would send horse-drawn surreys (buses) to the stations to pick up disembarking passengers and would take them to one of several overnight accommodations or wherever they were staying. The trains were major players in the expansion and growth of the village. Many businesses relied on sending or receiving goods via rail, including the lumber and grain mills. The trains were not without problems, however. In 1911, The Michigan Central Railroad had a head-on train wreck between Grant Street and Cass Avenue. When the two trains collided, cars flew off the track.

Vassar still uses rail to carry goods and has seen only a few other minor incidents over the years. Without this outside connection, things may have turned out differently. Today the brick station sits empty except for storage; the wood station was removed and is now restored and used as retail space in Mayville, Michigan. All that is left is a dirt spot where many memories were once made.

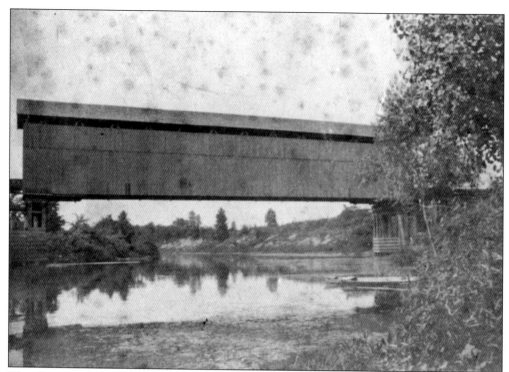

This photograph shows a covered bridge one might expect to see in Vermont. This is the original Pere Marquette Railroad Bridge crossing the Cass River near South Main Street. The photograph was taken in 1896. This bridge was used for many years before it was replaced. (Courtesy Bullard Sanford Memorial Library.)

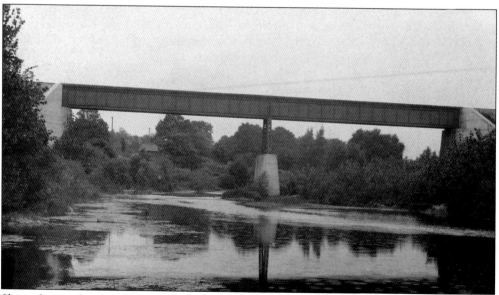

Shown here is the train bridge that replaced the wooden one. This photograph was taken in 1910 and looks the same today. Today this section of rail is rarely used, but one can imagine the many trains that passed over it, coming or going to the next destination.

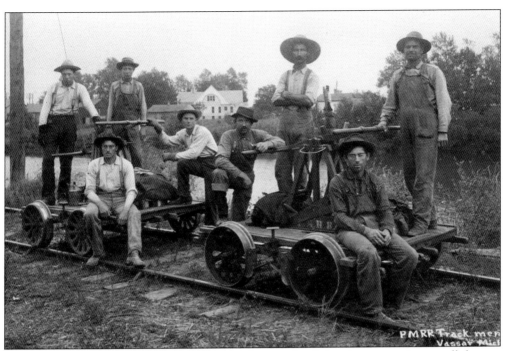

The Pere Marquette Railroad tracks also carried a spur that led to downtown. It went all the way to the Farmers Elevator located on the corner of Cass Avenue and East Huron Avenue, where the rail trail starts today. This *c.* 1910 photograph shows trackmen on this spur behind the little brick building. The man sitting on the front left is Edward Roth.

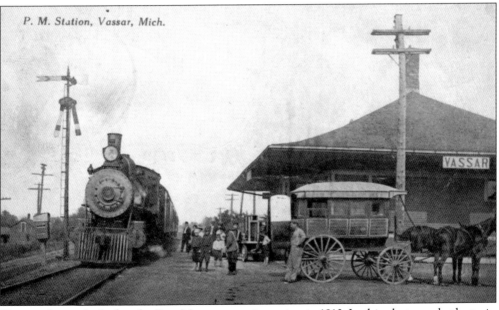

This was how it looked at the Pere Marquette train station in 1910. In this photograph, the train is coming in, full of people and freight, and passengers are waiting to board. The man leaning against his horse-drawn bus is Herb Service. He worked for Humes Livery Stable and was waiting patiently for the train to stop, so he could pick up passengers.

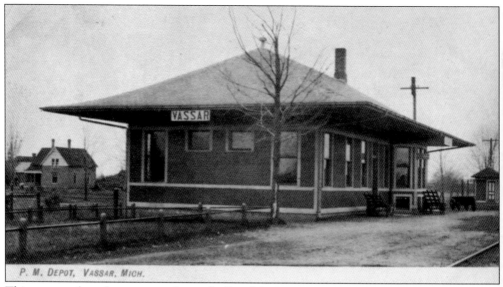

P. M. DEPOT, VASSAR, MICH.

This seems to have been a quiet day at the Pere Marquette train station. This view was taken in 1911 and looks from Goodrich Street towards East Street. Today all that is left is a bare spot as the station was sold and moved to Mayville.

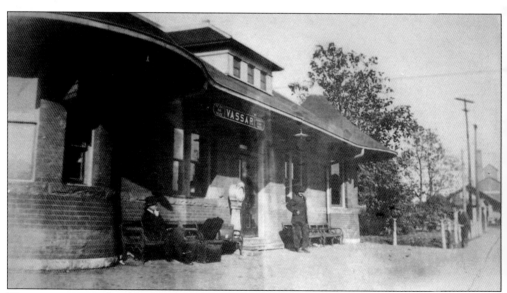

The impressive redbrick station that belonged to the Michigan Central Railroad is seen in this rare trackside photograph taken in 1909. A couple of men wait for the train to pick them up—otherwise, things look quiet. Used for many years, this station has been used for storage for the past 20 years. (Courtesy Buck Service.)

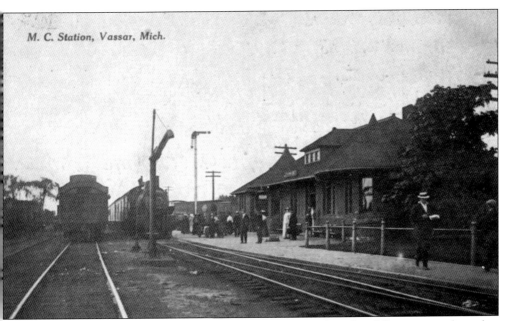

M. C. Station, Vassar, Mich.

This photograph shows a wide angle of the Michigan Central Railroad Station on a busy day. This photograph was taken in 1913 and shows a train coming in and passengers waiting to board. Another section of train cars sits idle on the next track. This view is looking from the East Huron Avenue/M38 track crossing.

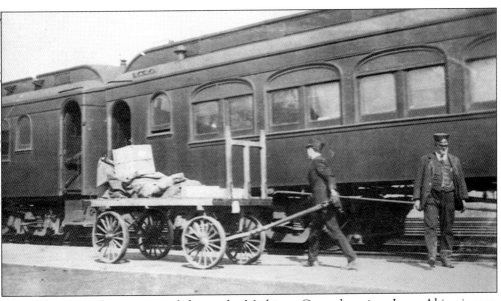

This 1920 image shows a typical day at the Michigan Central station. Leon Akins is seen pushing a baggage cart to a waiting train. This was one of several trains per day that passed through Vassar in years past. Today only freight trains pass through the area. (Courtesy Vassar Historical Society.)

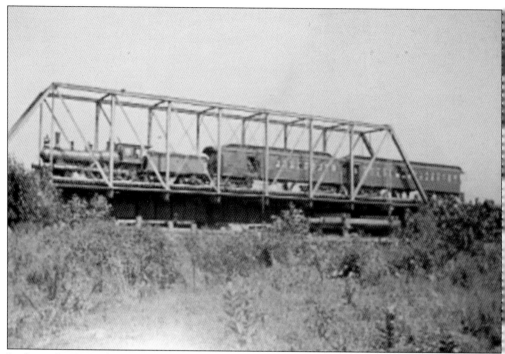

In the early 1900s, the Michigan Central Railroad replaced the old train bridge crossing the Cass River. This image shows the first train to cross the new train bridge—an event that was cause for a community celebration. This view is completely altered today.

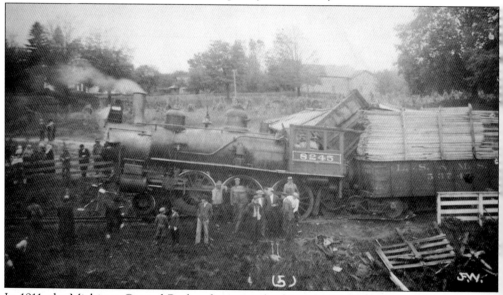

In 1911, the Michigan Central Railroad was involved in a major head-on crash on the tracks between Grant Street and Cass Avenue. This image shows one of the trains after the other engine was removed. One of the engineers was killed after the violent impact of the engines meeting at full steam. During this time in history there were no televisions or other electronic gadgets, so people turned out by the hundreds, making the wreck into a community event. (Courtesy Buck Service.)

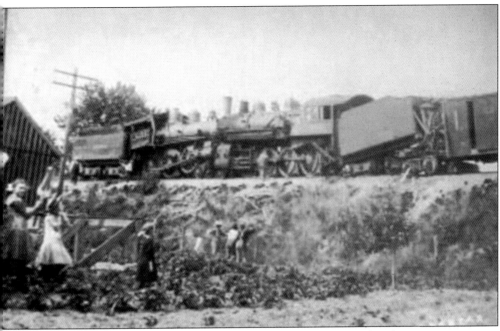

This is the train wreck from a different angle. It's possible to see how fast the trains were going by the impact the collision had on the cars. After a few days' clean up, the tracks were back in service.

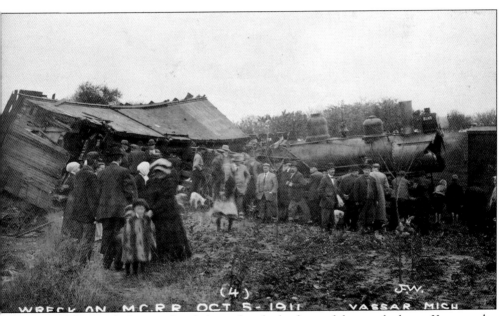

This view of the wreck shows a detailed, up-close look of one of the wrecked cars. You can also see the one engine. Notice how many people showed up to gawk at the wreck. Today you could not even get within a mile of a train wreck, yet these people were allowed to touch it.

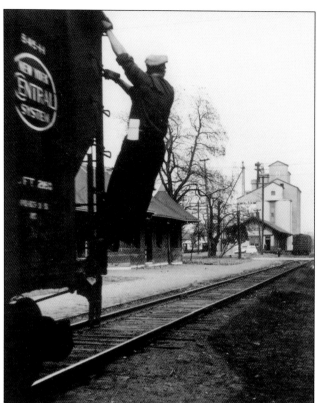

This classic image was taken on the tracks in front of the Michigan Central station. The freight train is backing up, and the guide man was hanging off the end to help guide the engineer as he backs up and hooks to another string of cars. This 1950s image is looking towards the East Huron Avenue/M38 track crossing.

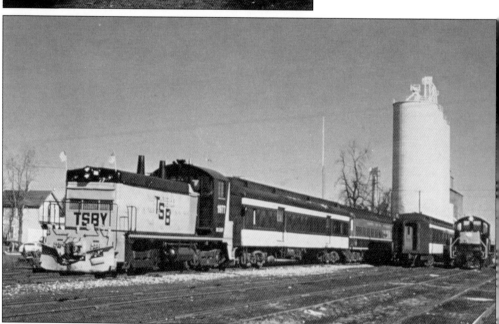

On May 15, 1978, the Tuscola and Saginaw Bay Railway (TSBY) leased some retired train coaches and held an open house for the City of Vassar. The TSBY was only two months old at the time. The event included free train rides. The train is shown in front of the former Michigan Central Station, which the company also leased as its offices.

Seven

AGRICULTURE

Agriculture has always been important to the Vassar area. When the first settlers arrived, naturally some were farmers; as the village grew, so did farming. In 1854 a small gristmill was attached to the North Sawmill. Both of these were originally under the ownership of North and Edmunds. In 1858, the Vassar Mill Company built a flourmill. Around 1864 B. F. McHose purchased the property, and it ran under his ownership for many years. The mill was four stories tall, including a basement. This mill had a capacity of producing 300–400 barrels per day and was considered one of the best in the country.

In 1868, North and Seldon began operations of the Vassar Woolen Mills. The company quickly outgrew the original mill building, and in 1882, it constructed an impressive brick building; it became an important business in the Saginaw Valley. The mill was said to have the best quality goods in the state. In 1878, R. A. and F. Miller built a grain elevator just a little ways behind the woolen mill. The elevator had about 40,000 bushels per annum and was located with easy access to the train depot. They also dealt in building materials of all kinds in addition to the grain business. Those were some of the many businesses that farmers could go to in the early years.

As time passed, Vassar became home to several berry farms located just outside the city. Dairy farmers supplied the Vassar Dairy and the creamery, or had their own dairy like Andreychuck Dairy (located on Cass Avenue across the river from Beulah Park) and Riverview Dairy. Riverview was located on the curve just below the cemetery hill. There were several other Vassar Dairy locations over the years as well. A poultry plant was also located just a few steps from the Michigan Central depot. Vassar also had several meat stores at one time or another. Vassar has always been good for all sorts of farmers.

The best of wives will always use BELL'S Soap, for that excels All other brands in purity, So purchase none but BELL'S.

One of several hardware stores to supply Vassar was Sanford, Lyon, and Company, located in the town clock building. A farmer could go there and buy farm wagons as well as farm tools. Common folk could also go here and buy what they needed at home. This Victorian trade card was handed out to the store's customers in 1883.

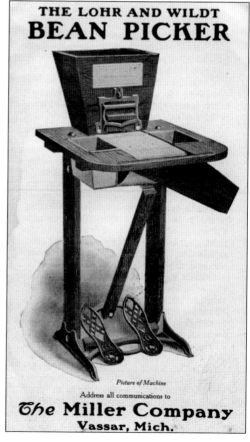

THE LOHR AND WILDT
BEAN PICKER

Picture of Machine

Address all communications to

The **Miller Company**
Vassar, Mich.

In the early years farmers could go to the Miller Grain Company to sell their produce or buy products they needed around the farm. One contraption they could buy in the 1890s was this bean picker. This brochure praised the help and ease this machine would give around the farm.

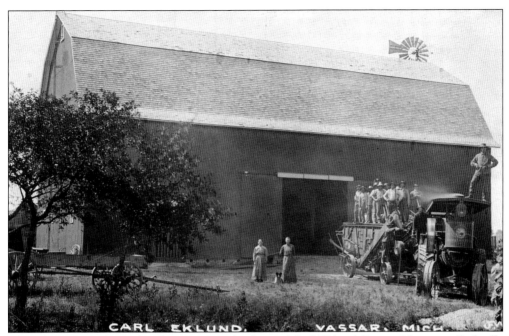

This photograph shows threshing time at the farm of Carl Eklund. Located between Richville and Vassar, the farm was very productive. This photograph shows Carl standing on the roof of his steam engine. His wife and mother are seen to the left of the steam engine with the family dog. Notice how many men it took to work the field.

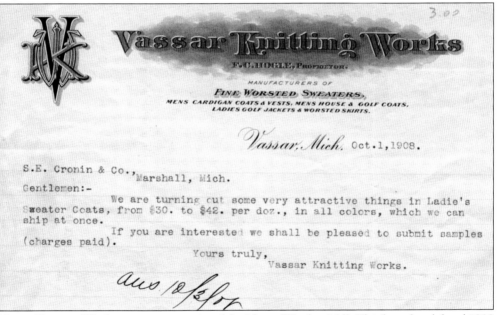

Vassar Knitting Works was a component of the Vassar Woolen Mill. This letterhead dated 1908 shows the company was known for its "fine worsted sweaters" among other woven items. Located where the city hall is today, the building caught fire and the third floor was destroyed. The Butcher Folding Crate Company moved into the building, and the building became a two-story crate factory.

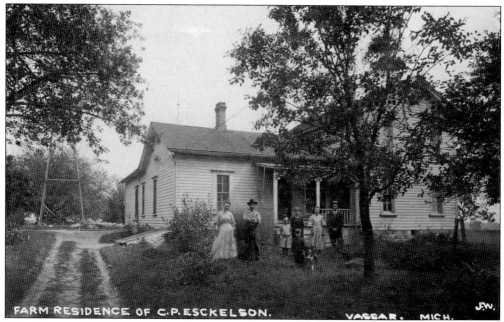

FARM RESIDENCE OF C.P. ESCKELSON. VASSAR, MICH.

This photograph was taken around 1910 and shows the main house of the C. P. Esckelson farm. Located between Tuscola and Vassar, it was one of many successful farms built with the assistance of the many Vassar businesses. Mr. and Mrs. C. P. Esckelson stand to the left of the photograph; their kids are to the right.

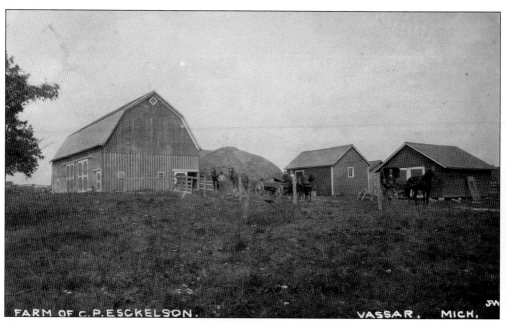

FARM OF C.P. ESCKELSON. VASSAR, MICH.

This photograph shows the rest of the C. P. Esckelson farm. It seemed to have been a large farm by the looks of the barn and the other farm buildings. Notice the farmhands in the photograph. A couple of them are showing off the family buggies. This photograph was taken the same day as the homestead photograph.

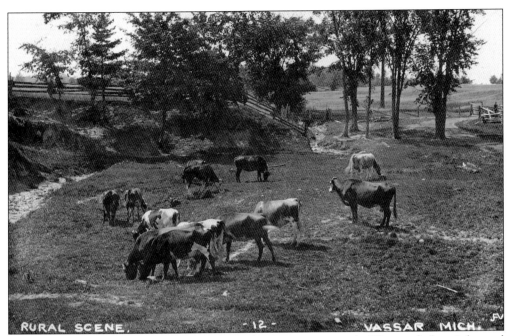

This 1910 photograph shows a typical sight in the Vassar countryside. This cattle farm is located on the corner of Pinkerton Road and South Vassar Road. This scene shows the farmer's grazing field. Though the cows are gone, the area otherwise looks similar today. Many farms like this one supplied the meat markets in town and were a good way for a farmer to make money.

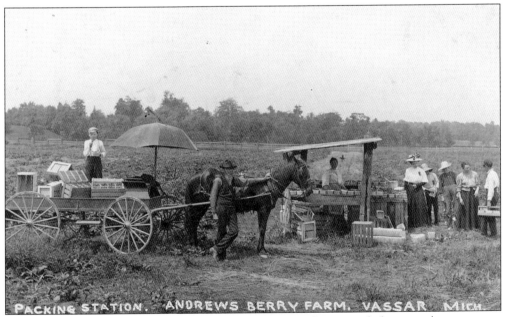

Seen here around 1911, the Andrews Berry Farm—one of many such farms in the area—was located between Vassar and Millington. This was the farm's packing station. Notice the little boy in the back of the berry wagon. As the adults buy and sell berries, he is sneaking a few nibbles.

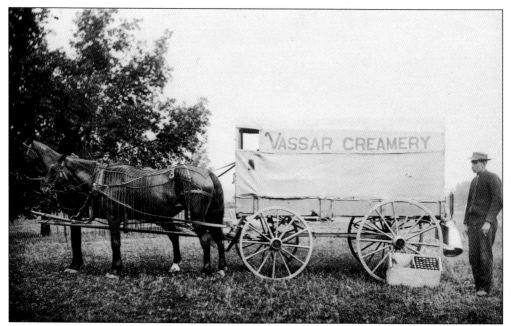

The unidentified man in this photograph from 1911 was a driver for the Vassar Creamery. He would have been a familiar scene on the streets of Vassar, just like the milkman. The creamery he drove for was located on Cass Avenue across the street from the Reliance Mill Company, now known as the back parking lot in downtown Vassar where shoppers park to go into the stores or take in a movie.

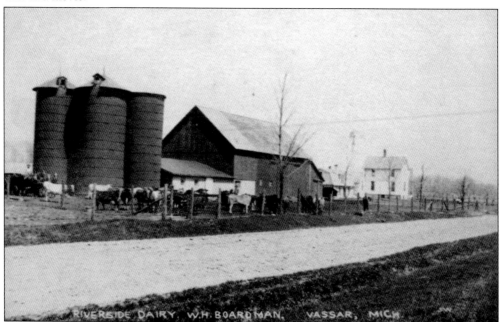

The Riverside Dairy stood just outside the village limits. This photograph shows the complete dairy spread from the Frankenmuth Road curve looking towards South Main Street. It was an impressive sight in the early years. All that is left of this scene today are the main house and the milk house. (Courtesy Vassar Historical Society.)

This photograph shows the illustration of a printing plate used by the Vassar Mills, later known as the Reliance Milling Company. This was one of several images that would have been printed on flour sacks in the 1860s. This image was discovered, printed on paper, in the wall of a home in Vassar that was being renovated.

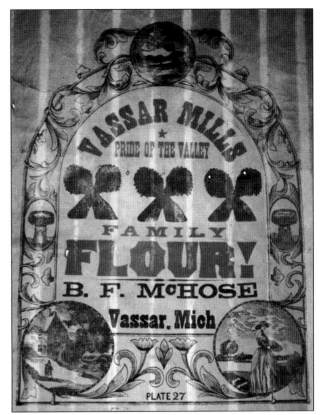

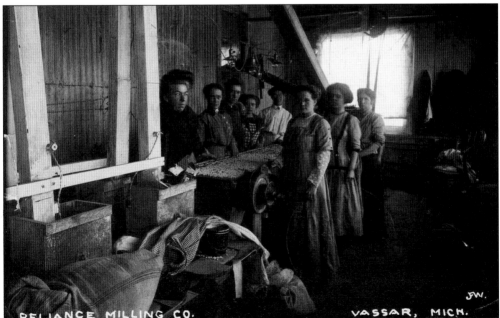

This rare image shows the female workers at a sorting table inside the Reliance Mill. It does not look like they were having much fun. This image was taken on the mill's second floor in 1910. Notice the hairstyles and the absence of hairnets. Things were very different back then.

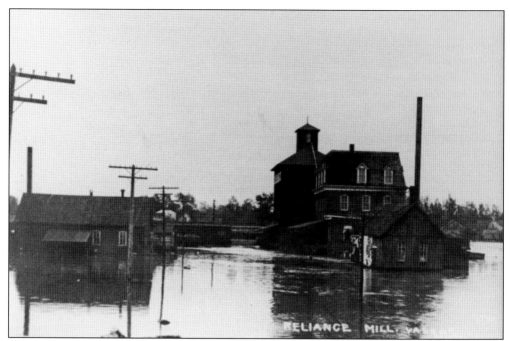

The Reliance Mill was no stranger to floodwater, as seen in this 1912 photograph. The little building to the right of the photograph was a coppersmith shop. The building across the street was the Vassar Creamery, owned by Tom Halpin. He was well known for his premost [stet] cheese. The creamery moved shortly after this photograph and is now known as Pinconning Cheese. (Courtesy Bullard Sanford Memorial Library.)

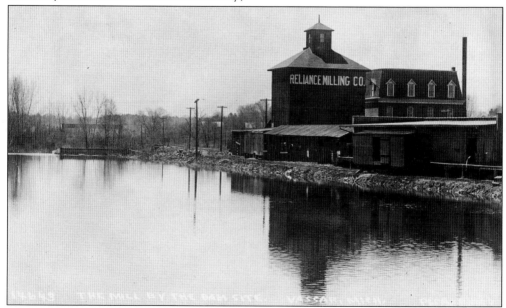

This photograph shows what the Reliance Milling Company looked like from the bridge. It made for an impressive scene to those visiting Vassar. Notice the railroad spur running along the river. This belonged to the Pere Marquette Railroad and continued up to the corner of Cass Avenue and East Huron Avenue. This photograph was taken around 1915.

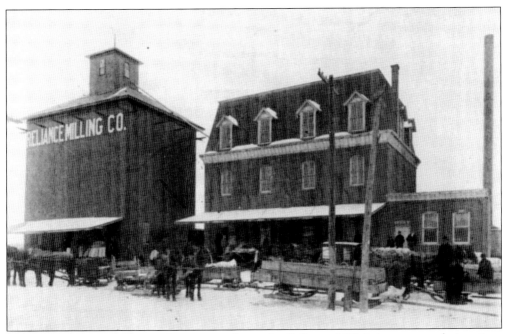

This 1910 photograph shows a busy winter day at the Reliance Mill. It is an unusual view since horses and buggies and not horses and sleds were normally pulled up out front. This photograph also gives a really good look at the mill's impressive architecture. The mill fell out of use about 40 years ago and was torn down in 1985. (Courtesy Vassar Historical Society.)

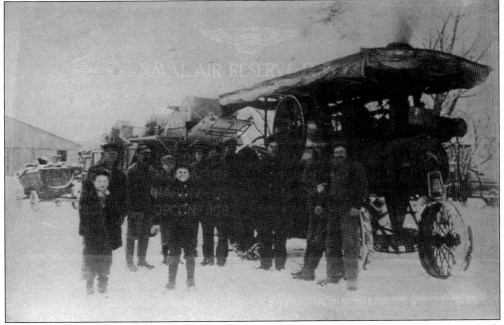

One of the farmers who would have used the Reliance Mill was John Tinglan. This photograph from 1920 shows John, his children, and farmhands during winter threshing. Notice the impressive steam engine and other equipment that they used. The Tinglan farm was located along M15 between Vassar and Millington. (Courtesy Vassar Historical Society.)

GRUBER FARM EQUIPMENT - VASSAR, MICHIGAN

In the 1940s, farmers could go to Gruber Farm Equipment located on top of the hill at 948 West Huron Avenue. This photograph shows the outside of the store. They specialized in the International Harvester brand along with other farm-related equipment. William Gruber and Glenn Roth originally owned it. The latter man started Roth Hardware, and William Gruber kept the store running for many years.

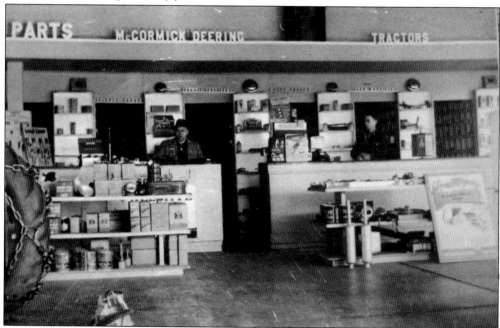

This 1949 photograph shows the interior of the Gruber Farm Equipment store. Owner William Gruber is shown on the left side of the photograph, and his assistant Elion Baker is on the right side. This store carried everything a farmer needed to maintain his equipment. The store looks well stocked at the time of this photograph. (Courtesy Vassar Historical Society.)

Eight

GRAB YOUR WADERS

Vassar sits in a low area of the Saginaw Valley. Most residential areas and some businesses were located on top of the hill that gently sloped down to meet the Cass River. Most of the businesses were located in this area just below the hill on both banks of the Cass River, so they were quite vulnerable to floods.

In fact, flooding has been a big part of Vassar's history, and people who lived, worked, or owned businesses in this area have become accustomed to water invading their spaces. It became a way of life.

In the early years, the flooding would be no more than ankle deep. In the early 1900s, however, the Moore Drain was dug from the farmers' fields in the country straight through the heart of town to connect to the river. Floods became more prevalent as not only the river, but now the drain ditch too, overflowed their banks. Even still, flooding was not much more than knee deep. In 1948, Vassar experienced a flood that many said was the worst in the town's history: water rose to 20 feet, 8 inches.

Little did the town know that this was bathwater compared to what would happen in 1986. That was the Vassar flood of all floods to date. The water rose to unprecedented levels: 24 feet 8 inches. Some businesses were flooded three-quarters of the way to the second floor; in those that had one floor, the water was nearly at roof level. This flood gave Vassar a stigma that has affected the town for over 20 years. Many homes and businesses were torn down, but some of those that have sat empty for many years are finally beginning to breathe life again. Vassar is in the stages of rebirth, but as in days of old, when the water rises, people work together to get the job done.

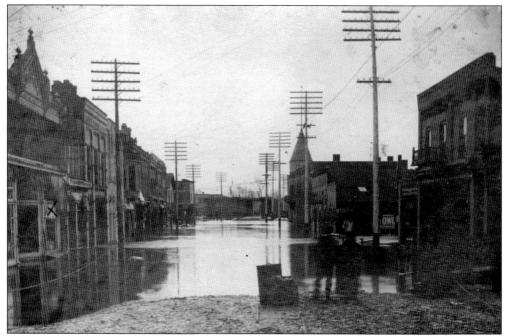

Downtown Vassar is a ghost town in this photograph of the 1903 flood. Only a handful of people seem to be amused looking at the water. The flood was in early spring, which explains why the men in the photograph are wearing winter coats. To the front right of the photograph is the U.S. Post Office.

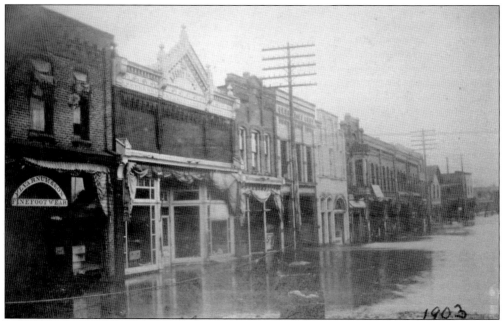

This is another view of downtown Vassar during the spring flood of 1903. The storefront at left was the P. L. Varnum and Son Fine Foot Wear Store. This photograph also illustrates how impressive the downtown once was. Though Vassar's population was small, the grand style and design of the buildings gave people the sense that they were in a big town. (Courtesy Buck Service.)

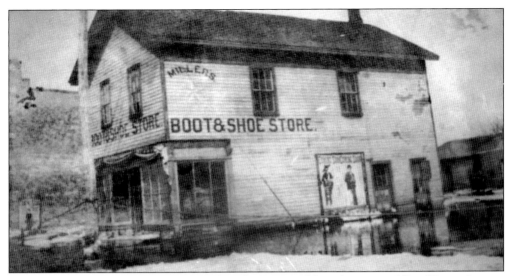

Miller's Boot and Shoe Store was located on the corner of Cass Avenue and East Huron Avenue where the State Bank building is located today. This image shows the store during the winter flood of 1904. Notice the ice floating on the water. (Courtesy Buck Service.)

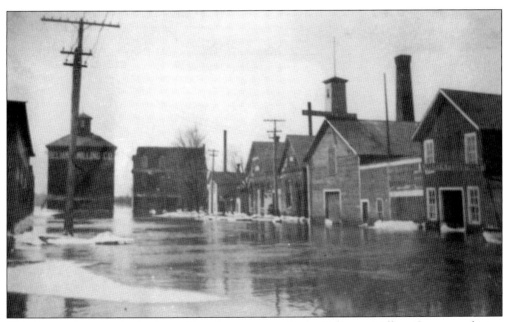

This impressive view looks down Cass Avenue towards the Reliance Milling Company during the flood of 1904. The three attached buildings to the right were a livery stable, the Vassar Water Works building (with smokestack), and the Reliance Milling Company (straight ahead). Today all of this is gone, and the back parking lot is in its place. (Courtesy Buck Service.)

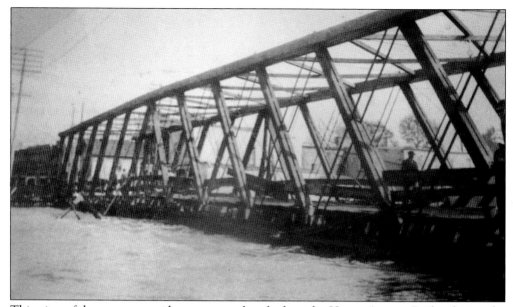

This view of downtown provides a rare up-close look at the Huron Avenue Bridge during the flood of 1904. Notice how high the water was. A little higher and the bridge would have been closed. (Courtesy Buck Service.)

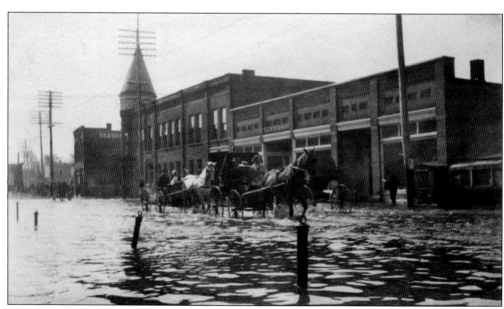

This unique view of the flood of 1904 shows horses and buggies trotting water in front of the Columbia Hotel. Notice the horse hitching post on the left side of the photograph.

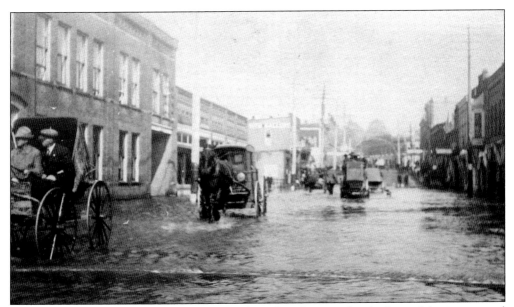

This is another unique view of the 1904 flood. In this photograph it looks as if this is a normal day for downtown Vassar, but it is not. There is floodwater across the streets, yet the many horse and buggies seem unaffected. The men in the front buggy at left appear to have been having a good time. They are in front of the Columbia Hotel.

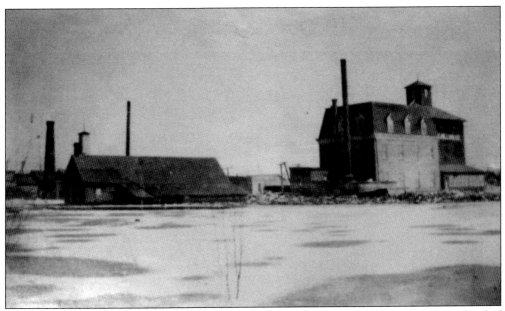

This unusual view of the back of the Reliance Milling Company was taken during the flood of 1904. The building to the left of the mill housed a coppersmith shop. In the background stands the chimney that belonged to the Vassar Water Works. This view is looking towards the Columbia Hotel corner of Cass Avenue and East Huron Avenue. (Courtesy Buck Service.)

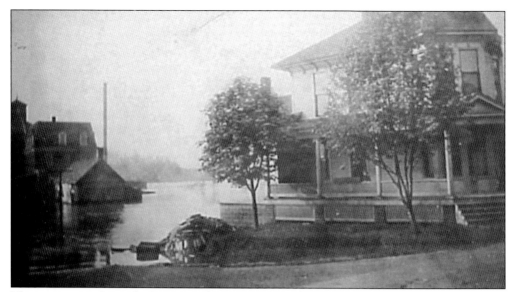

This rare image shows the house on the corner of South Main Street and Cass Avenue during the flood of 1904. In the background stands the Reliance Milling Company and the coppersmith shop. The house looks the same today with the exception of the porch, which has been altered. (Courtesy Buck Service.)

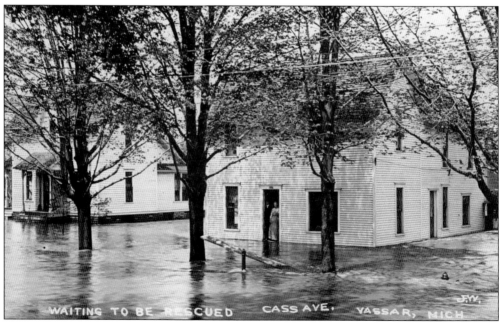

No other Vassar street is more prone to flooding than Cass Avenue. Once, this formerly tree-lined street was the prettiest in town. Like a lot of things in life, something nice usually has a dark side and floods became the dark side for Cass Avenue. This photograph shows the flood of 1912 and a couple that was trapped in their home.

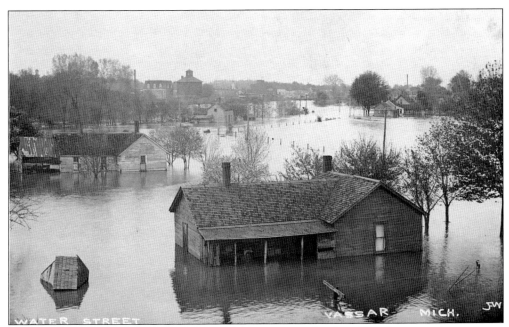

This photograph shows another residential street prone to flooding. This home was located near the corner of Cherry Street and Butler Street. This photograph was taken during the flood of 1912. In the background stands the Reliance Milling Company and downtown Vassar, just across the river.

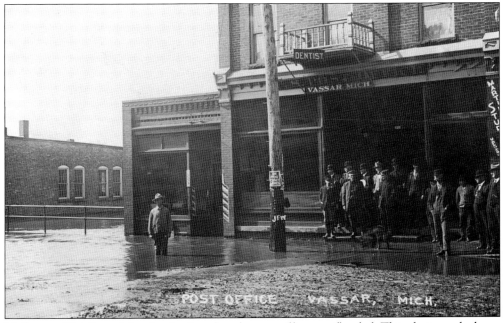

Mail was still delivered despite the fact that the post office was flooded. This photograph shows the post office and the little barbershop to the left during the flood of 1912. This post office was located to the left of today's Vassar Theatre. Notice that the man standing in the water was knee deep while the curious men and dog were barely getting their feet wet.

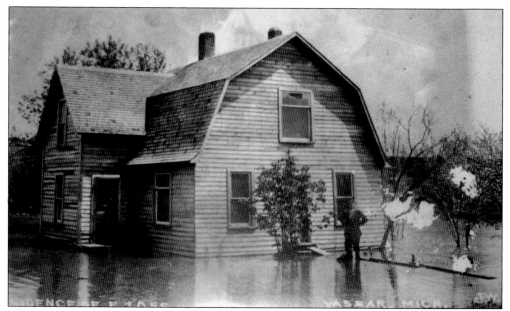

This was the home of Ernie Loss, the town barber. The house was located just off of Cass Avenue on Lincoln Street. Ernie is shown wearing his waders, standing on his front walk. This house was razed after the 1986 flood destroyed what was left of it. This photograph shows the flood of 1920. (Courtesy Buck Service.)

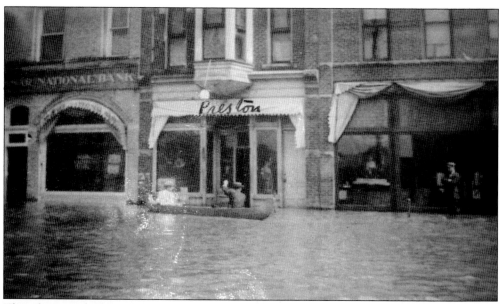

This photograph shows a common scene in downtown Vassar during the flood of 1920. The couple in the canoe appear to be enjoying themselves while the man in front of Atkins Hardware is not so amused. The canoe is in front of the Vassar Confectionary, and to the left is the Vassar National Bank. (Courtesy Buck Service.)

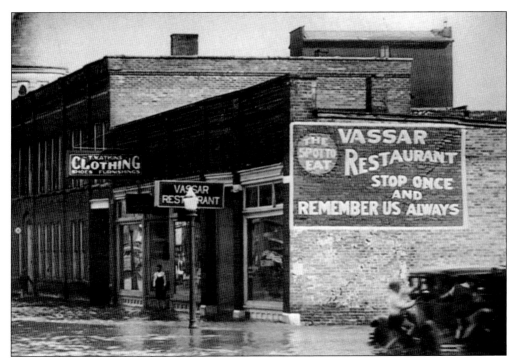

In the late 1920s, another flood would invade downtown Vassar. This photograph shows the Columbia Hotel, T. W. Atkins Clothing Store, and the Vassar Restaurant inundated with water. The kids playing on the car in the front right of the photograph appear to be having fun splashing around in the water. (Courtesy Vassar Historical Society.)

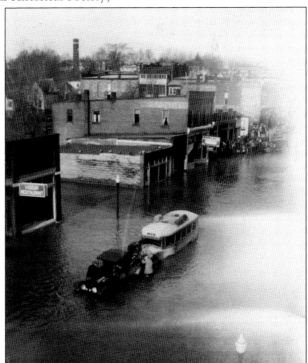

This is another 1920s flood. This unique view was taken from the roof of Atkins Hardware Store looking towards the middle of downtown. It looks as though someone was trying to drive a bus through the water and stalled. The wrecker has become nearly submerged as its operator tries to hook up the bus and remove it from the water. The post office building seen here became Tucks Billiard Hall.

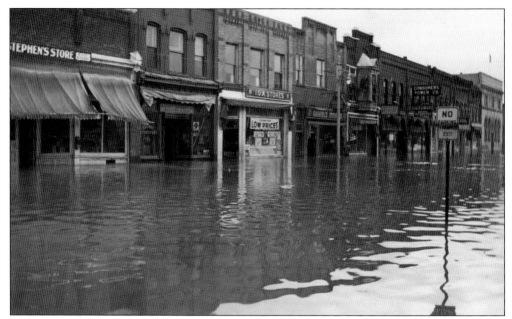

In 1942, Vassar once again filled with river water. This view shows the left side of downtown looking towards Cass Avenue from the theater. Stephen's Store advertises itself as a "5 and 10¢ Store." Next to Stephens is the Beatrice Creamery, where farmers could have their cream weighed and sold. Also shown are the IGA Store, the Gamble Department Store, Vassar Confectionary, and Atkins Hardware, among others.

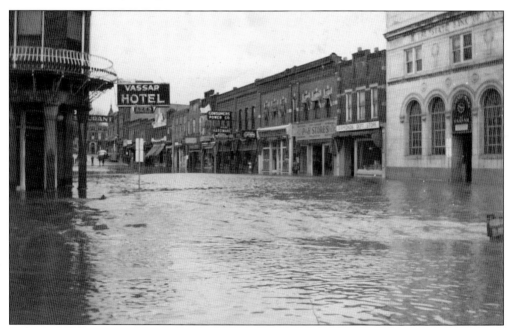

This view of downtown Vassar during the flood of 1942 looks from the corner of Cass Avenue and East Huron Avenue. The Vassar Hotel is on the left corner. Across the street is the State Savings Bank, Diamonds Department Store, the P and H Dry Goods Store, Reichle's Shoe Store, Atkins Hardware Store, and the Vassar Confectionary among others.

Williams Drug Store was just a few years old when it was invaded by floodwaters, as seen in this 1948 photograph. Williams Drug Store also had a soda fountain, so that while customers were waiting on their prescriptions, they could also each nurse their sweet tooth with a hot fudge sundae. (Courtesy Bullard Sanford Memorial Library.)

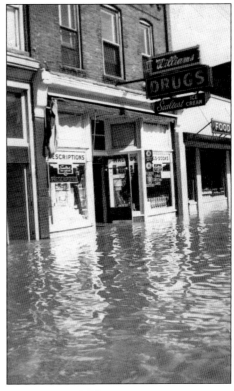

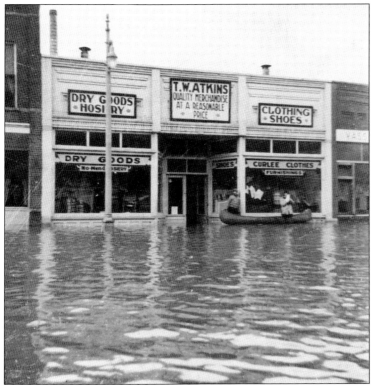

This photograph shows the T. W. Atkins Clothing Store during the flood of 1948. It looks as though these men are window-shopping via canoe. This store, along with the Vassar Restaurant to the right, would eventually become Dancer's Department Store. It was very popular in downtown Vassar until the flood of 1986.

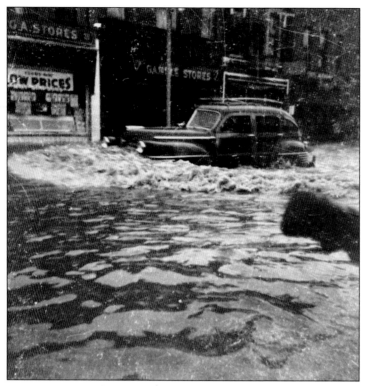

The flood of 1948 had its share of daredevils. This photograph shows one such person driving his car through the flooded downtown. The water reaches to the bottom of the doors and made big waves as it pushed ahead. The car is just passing the Gamble Department Store.

The curious onlookers gathered in front of the Gulf Gas Station on the corner of Cass Avenue and East Huron Avenue looking at the flooded downtown in 1948. Even with the floodwater, the State Bank still flew the American flag, declaring that no flood would take them down. And this was true—until the flood of 1986. The State Bank constructed a new building on higher ground after that.

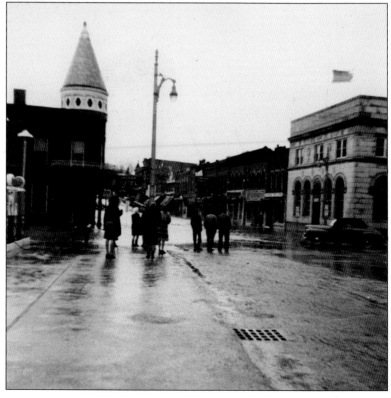

The only way to get groceries during the flood of 1948 was via boat as seen here. The curious stood outside and milled around in their waders as if nothing was happening. Notice some of the prices in the window of Simpson's IGA. Pork hocks were 19¢, and cigarettes were $1.21 a carton.

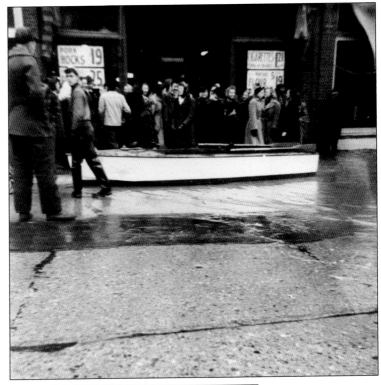

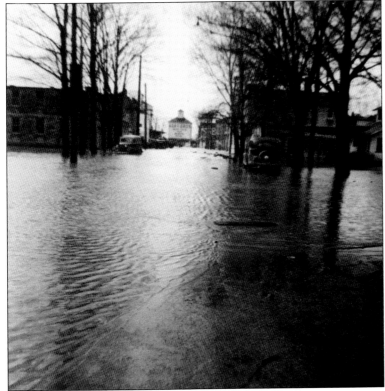

This impressive photograph shows Cass Avenue during the flood of 1948. The photograph was taken on the corner of East Oak Street and Cass Avenue looking towards the East Huron Avenue business district. The building at the far end of the street is the Hart Brothers Elevator, formerly the Reliance Milling Company.

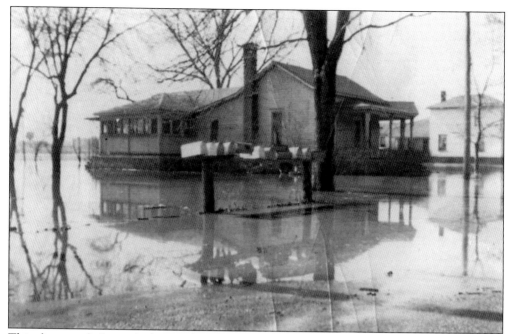

This photograph shows the home of Herb and Georgina Service located on Cass Avenue across from Chestnut Street. The house was surrounded by the 1948 floodwater. This house is no stranger to floods. It looked much worse in the flood of 1986. The home looks similar today but the front porch has been altered.

The flood of 1986 was the worst flood in Vassar's history to date. This flood would alter the town and give it a bad reputation that lasted 20 years. This photograph shows the Cass Avenue viaduct, which normally has an 11-foot-11-inch clearance. It is seen here with only about a 2-foot clearance. When people took a boat to inspect their homes, they would have to duck their heads or hit them as they passed under.

This photograph shows why the 1986 flood devastated downtown Vassar. This photograph looks from the South Main Street corner towards downtown. Notice the water lapping at the bottom of the awnings the closer the street gets to the Cass River. With water that high outside, this meant that the water *inside* the stores was only a few feet from touching the ceilings.

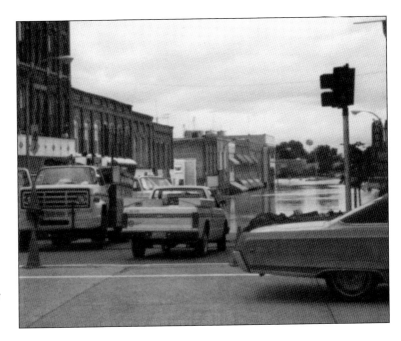

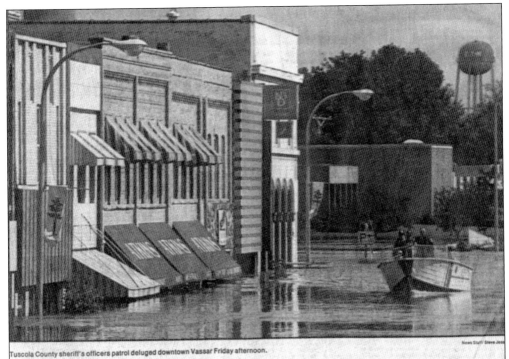

Tuscola County sheriff's officers patrol deluged downtown Vassar Friday afternoon.

Vassar reeling from the '100-year flood'

The local newspapers had in-depth coverage of the 1986 flooding. This photograph from the *Saginaw News* shows a scene that looks out of place, yet during this time it was normal. The Tuscola County Sheriff's Department sent officers in a boat patrolling the downtown. Notice how high the water was compared to the storefront. (Courtesy *Saginaw News*.)

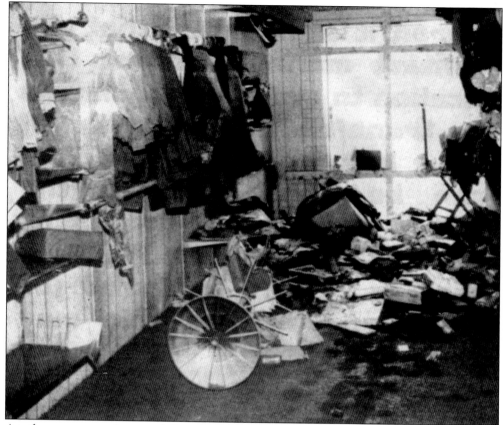

Another newspaper photograph from the *Saginaw News* shows the inside destruction to Dancer's Department Store. This was only a small corner of the store, but serious devastation is apparent. The middle-upper portion of the photograph shows a pair of shoes that landed on top of the clothing-display rack. The store never recovered from the flood and was torn down. (Courtesy *Saginaw News*.)

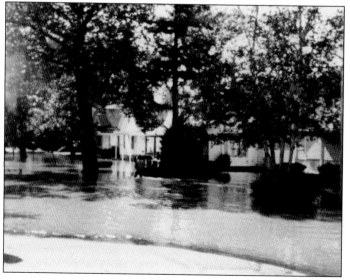

The 1986 flood broke many records in Vassar. One of those records was broken when the floodwaters spilled over onto South Main Street. This has never happened before, and it was a strange sight to behold. This photograph is looking from the Cass Avenue and South Main Street corner. Notice the man wading in knee-high water.

Nine

RELIGION

Spiritual beliefs were fundamental to the early settlers of Vassar. That became manifest in 1851 when the first traveling circuit of the Methodist Church came to town. In 1855, the Presbyterian church was built on Prospect Street. This wooden building would be the first house of worship in Tuscola County. Other believers would meet at the homes of fellow believers as the first Christians had, or under the large canvas tents popular with traveling revivalists. One of those early congregations to hold their first worship under a 50-foot tent was the Seventh Day Adventist church in 1865. The church organized and their first "permanent" house of worship was dedicated in 1872. In 1869, the Methodist church built a structure on North Main Street, an impressive all brick construction for a cost of $7,400.

Over time, the First Baptist Church would also be built on Division Street right next to the city park. In 1895, the Presbyterian church moved into a new all-brick building ideally located on the corner of Washington Street and West Huron Avenue on the slope of the hill. The former church was moved farther down the street and another Christian denomination took over the use of the building and is still in use today. In 1929, the second Presbyterian church burned, leaving only the outside walls. The congregation quickly went to work reconstructing their beloved church. Today it looks similar but with some structure changes and a modern addition.

The Methodist church had undergone some additions and alterations but when people step into the front door, they can still see the 1869 charm of a small-town church. Vassar now has several different denominations. Today, the churches hold their annual fall bazaars, choir concerts, dinners, and host special guest speakers, among many other community events. The Methodist church also became the home of the Vassar Boy Scout Troop 201. Many young men have joined the ranks of this proud community group, and it is still a great influence to the area youth.

This is a rare look at the first Presbyterian church building on Prospect Street. This photograph as taken in the 1890s and the church looks as though it could use a good coat of paint. The standpipe water tower looks new and was located right next to the church. The water tower would remain a historic landmark until the 1990s. The church building was constructed in 1855. (Courtesy Bullard Sanford Memorial Library.)

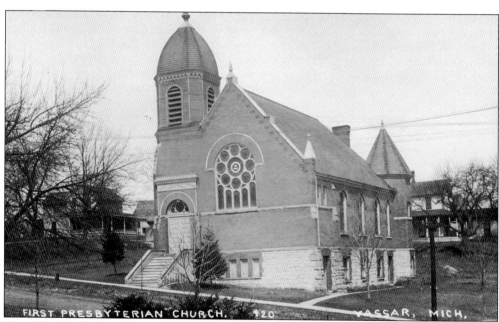

FIRST PRESBYTERIAN CHURCH. #20 VASSAR, MICH.

This photograph shows the second Presbyterian church. This church building was constructed on the slope of the West Huron Avenue hill, right next to the city park. This photograph dates to 1909. The church is on the corner of Washington Street and West Huron Avenue. The white house to the left of the church was a doctor's home and office for many years.

The Presbyterian church had a boys' group called the Boys Brigade. This photograph from 1901 shows the boys in the group standing on the hill next to the church. The boys were outfitted with military-style uniforms provided by church member and prominent resident Mr. Joslyn. The boys would march around the basement of the church and then would participate in devotions. They would also participate in community parades. (Courtesy Vassar Historical Society.)

Shown here is the back of the Presbyterian church (before the fire) from Hillside Park in 1918. This view gives another look at the unique architecture. After the fire in 1928, these twin towers were removed, while other features of this church survived and were included in the new church construction.

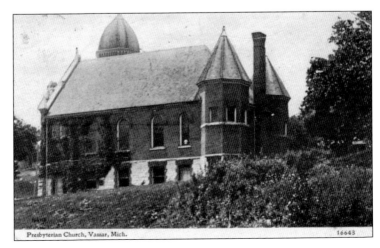

Presbyterian Church, Vassar, Mich. 16643

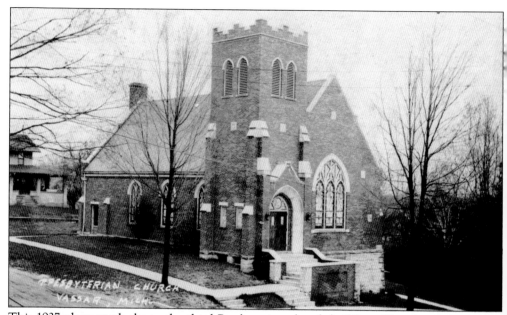

This 1937 photograph shows the third Presbyterian church building. The church burned in 1929, and the congregation quickly set about rebuilding. Although part of the original church was saved, there was room to completely update the facade at the same time. Today the church looks the same, and the interior has an old-world charm and warmth to it that is hard to find in a church today.

This rare photograph shows the Reverend E. W. Frazee. He was the pastor of the Methodist church from 1885 to 1889. This photograph was taken in Tibbitts Studio above the Exchange Bank in 1889. Pastor Frazee eventually retired and moved to California where he passed away in 1938 at the age of 98.

This view of the Methodist church was taken in 1908. This photograph shows the beautiful yet simple design of the original building. Over time, many additions were added to the church, including one that enclosed the original front door. Notice the horse hitching post and wood sidewalks across the street from the church.

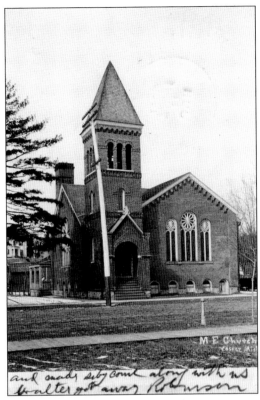

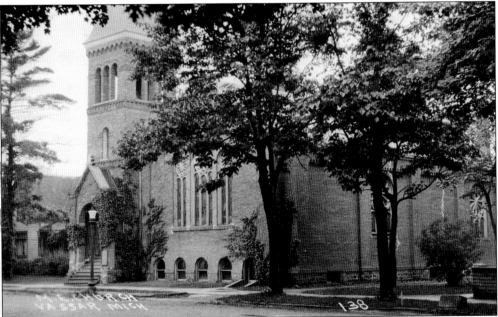

This 1940s view of the First United Methodist Church was taken from the corner of East Oak Street. The original church building has not had any alterations and additions as of the time of this photograph. The white gingerbread-style house to the left was the original parsonage of the church. Today the house is gone, replaced with a driveway and addition space.

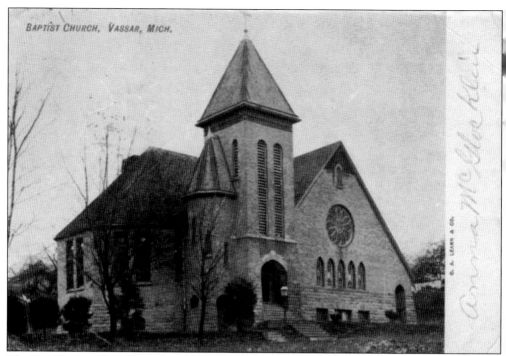

The First Baptist Church stood on Division Street on the side of Hillside Park. The building has seen a few alterations since this 1907 photograph was taken. The Baptist congregation approved a new building and now worship on Frankenmuth Road. In recent years, this has served as the home of the Nazarene church.

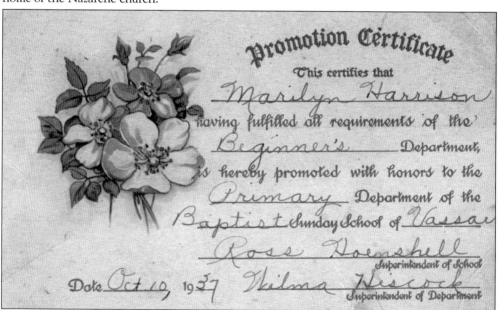

This promotion certificate entitled Marilyn Harrison to move to the next course in Sunday school held at the Baptist church in 1937. She was the daughter of Mr. and Mrs. Oswald Harrison who owned Harrison's Food Market next to the theater. She had two sisters and a brother who also went through the Sunday school.

Ten

A Look Back at the 1949 Centennial

Vassar formally became a city in 1944, but everyone remembered where they came from: a hard-working lumbering village founded 95 years earlier. Thus, as 1949 drew near, plans were underway to celebrate the 100th birthday of the Vassar community. Ken Priestly was head of the committee that planned the entire event. It was decided the festivities would be held the end of July 1949. Everyone in the city was encouraged to dress as pioneers, and the stores were encouraged to get in on the fun. A huge parade was planned, and many activities were organized such as a beard derby. It was made a law that no man of age would be caught without a beard during the festivities. If caught beardless, the men would be "jailed and fined," all in good fun, of course. There was a "preview of review" program and a kangaroo court as well as other programs and activities throughout town and at the high school. A special cake was ordered from and baked by Bill Buchman and the Vassar Home Bakery. There was a huge public ceremony where the cake was displayed and eaten by the attendants. Bill was so proud of his role in the centennial that he had a special photograph made of him and Ula North ceremoniously cutting the cake. It hung in his bakery for many years.

One of those attendants who enjoyed Bill's cake was special guest Gov. G. Mennen "Soapy" Williams. Ula North was crowned centennial queen. She won the title because she was the youngest daughter of Townsend North and the only living direct descendant to Townsend North. The highlight of the event was a huge parade. Everyone had a great time and to this day people still recall the excitement that electrified the town. Other important birthdays have come and gone in Vassar, but the 1949 Centennial will always be the best Vassar has ever had.

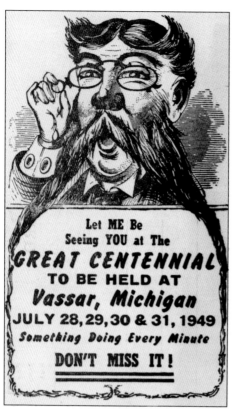

This promotional postcard would have been sent in the mail to remind people of the upcoming celebration. The illustration shows a Victorian man complete with handlebar mustache, keeping in tune with the era. They would have been sent a few months before the event so everyone could mark their calendars.

Let ME Be
Seeing YOU at The
GREAT CENTENNIAL
TO BE HELD AT
Vassar, Michigan
JULY 28, 29, 30 & 31, 1949
Something Doing Every Minute
DON'T MISS IT!

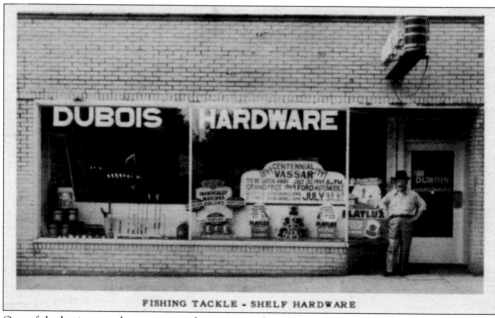

FISHING TACKLE - SHELF HARDWARE

One of the businesses that got in on the centennial action was Dubois Hardware Store. Located where Speedway Gas Station is today, it was one of several hardware stores in business at the same time. Mr. Dubois is seen standing in the doorway. The sign in the window advertised a raffle that would be held for the celebration with the grand prize being a 1949 Ford.

These lovely ladies were dressed for the occasion. From left to right are Georgia Ann Roth, Mary Roth, and Gladys (Service) Roth. Gladys made sure her daughters participated along with the rest of the Service family. Gladys and her husband, Glenn, recently opened their own hardware store and would have made sure to have been seen there. The photograph was taken in front of their home on Cass Avenue.

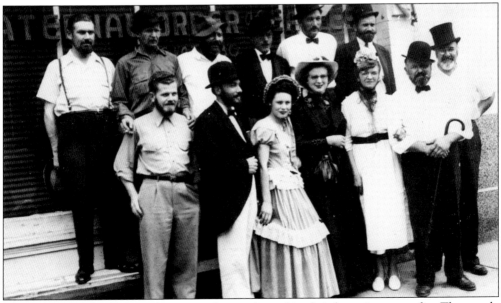

This is a group of well-dressed partiers who are dressed in their best pioneer outfits. The people in the photograph are unidentified, but they are standing in front of the Fraternal Order of the Eagles Hall to the left of the State Bank of Vassar. Notice the men have some sort of facial hair so they would not be jailed for running around town beardless.

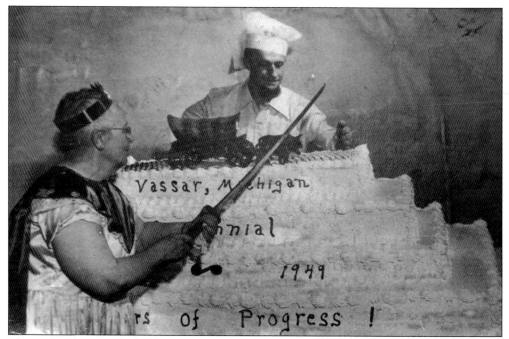

This is the photograph that hung in the Vassar Home Bakery for many years. Seen here is Bill Buchman, who is standing behind the centennial cake. Ula North is standing in front of the cake holding the "cake knife" and wearing her crown and cape. Bill is showing her where to make the first cut once the cake was revealed to the public. (Courtesy Vassar Historical Society.)

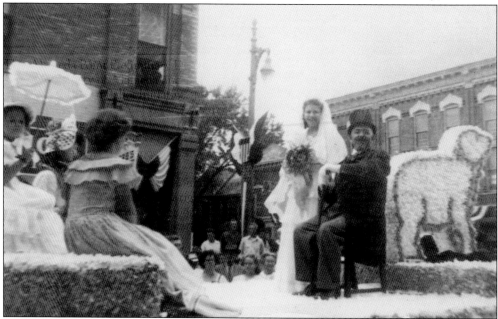

This was one of many floats in the centennial parade. The photograph shows the float just passing the corner of South Main Street and East Huron Avenue. The opera house building can be seen to the right and Erb's Food Store is the building to the left that they are just passing. The float appears to represent a makeshift wedding in the olden day.

Vassar not only had floats in the centennial parade but actors as well. This photograph shows Dorr Carr dressed as a barefoot woodsman complete with his rifle. Imagine running into him on a dead-end road. The photograph shows him stopped in front of Simpson's IGA. Mr. Carr was a well-known resident in Vassar for many years.

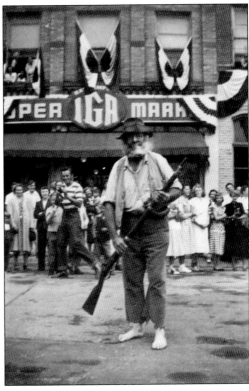

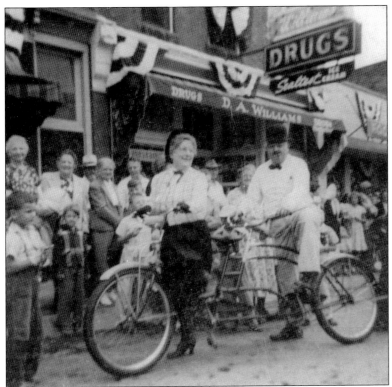

In this photograph one can feel the electricity and excitement that went through Vassar during the centennial. This photograph shows Hazel Honsinger and Doctor E. C. Swanson on an old-fashioned two-seat bicycle. They are in front of the William's Drug Store taking a breather. Doc Swanson, as he was known, was a beloved character and doctor in Vassar for many years.

www.arcadiapublishing.com

Discover books about the town where you grew up, the cities where your friends and families live, the town where your parents met, or even that retirement spot you've been dreaming about. Our Web site provides history lovers with exclusive deals, advanced notification about new titles, e-mail alerts of author events, and much more.

MADE IN THE USA

Arcadia Publishing, the leading local history publisher in the United States, is committed to making history accessible and meaningful through publishing books that celebrate and preserve the heritage of America's people and places. Consistent with our mission to preserve history on a local level, this book was printed in South Carolina on American-made paper and manufactured entirely in the United States.

This book carries the accredited Forest Stewardship Council (FSC) label and is printed on 100 percent FSC-certified paper. Products carrying the FSC label are independently certified to assure consumers that they come from forests that are managed to meet the social, economic, and ecological needs of present and future generations.

FSC
Mixed Sources
Product group from well-managed forests and other controlled sources

Cert no. SW-COC-001530
www.fsc.org
© 1996 Forest Stewardship Council

Find Your Place in History.